Illustrating
NATURE

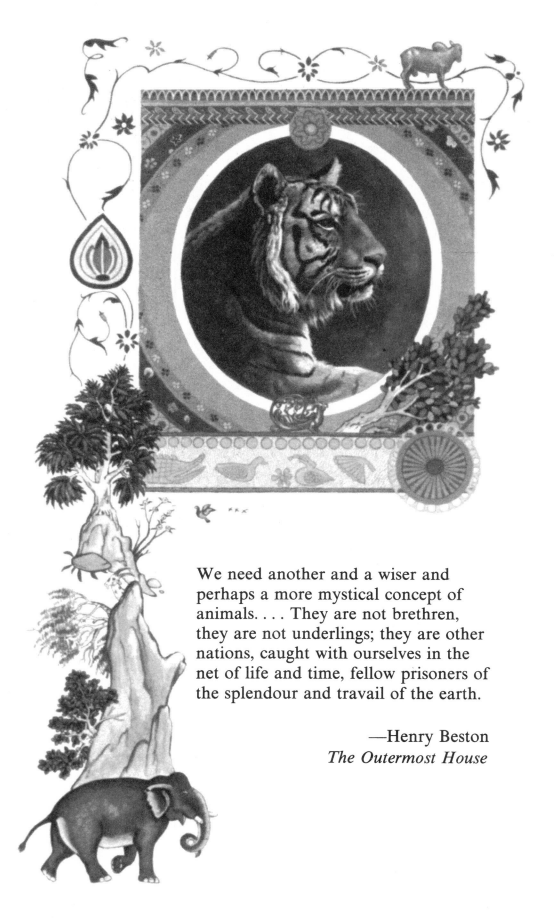

We need another and a wiser and
perhaps a more mystical concept of
animals. . . . They are not brethren,
they are not underlings; they are other
nations, caught with ourselves in the
net of life and time, fellow prisoners of
the splendour and travail of the earth.

—Henry Beston
The Outermost House

HOW TO PAINT AND DRAW PLANTS AND ANIMALS

Dorothea and Sy Barlowe

DOVER PUBLICATIONS, INC.
Mineola, New York

ACKNOWLEDGMENTS

Our thanks to all the dedicated people of science who have contributed to our knowledge through the years, to Barbara Burn for believing so enthusiastically in our book, and to Michael Shroyer and Mary Velthoven for helping us make this book a reality.

Bibliographical Note

This Dover edition, first published in 1997, is an unabridged republication of the work originally published in 1982 by The Viking Press, New York.

Library of Congress Cataloging-in-Publication Data

Barlowe, Dot, 1926–
 Illustrating nature : how to paint and draw plants and animals / Dorothea and Sy Barlowe.
 p. cm.
 Originally published: New York : Portland House : distributed by Crown, 1987.
 ISBN 0-486-29921-X (pbk.)
 1. Natural history illustration. I. Barlowe, Sy. II. Title.
QH46.5.B37 1997 1110
508'.022'2—dc21 97-23766
 CIP

Manufactured in the United States of America
Dover Publications, Inc., 31 East 2nd Street, Mineola, N.Y. 11501

CONTENTS

This book is dedicated with love to
Amy and Wayne, musician and artist,
who have added immeasurably to the
quality and happiness of our lives.

INTRODUCTION

The art of illustration is a form of visual communication that encompasses activities ranging from the portrayal of the structure of a bridge in an architectural drawing to the pictorial enhancement of a story in the field known as general illustration. It has become a vital part of the economy of our country; today the artist at his drawing board is involved in practically every aspect of the American way of life. From the attractive design of a pencil sharpener to the package around a bottle of perfume, there are very few commercial items that do not bear the imprint of some industrious artist plying his trade.

Our concern in this book will be the art of illustrating nature either for professional purposes or for personal enjoyment. Nature illustrations are used in guidebooks, textbooks, popular and scientific periodicals, and, occasionally, newspapers. One engaging example of how nature illustration fills a popular need is the prevalence of bird and flower painting in notepapers, greeting cards, and prints.

The portrayal of natural history subjects is a highly specialized branch of general illustration. It is also fascinating and personally rewarding. To depict a particular creature in its natural habitat can be a minor education in itself, for doing so requires the consideration of many different aspects of that animal's life. In order to show it properly, the nature illustrator must thoroughly research its manner of living. Where exactly does it live? What other forms of life coexist with it? What kinds of plants are prevalent in its typical environment? He must make certain that parallel life forms are consistent for the time of the year; that the young of one species are shown in what would be their appropriate size relationship to the young of another at that season, and so forth. These principles should be followed whether the subject is marine or terrestrial. Ecological factors must always be taken into account before pencil is put to paper. In the art of nature illustration, the artist is honor bound to tell the truth.

In a world geared to speedy, impersonal efficiency, it is perhaps anachronistic to laud the virtues of patience and meticulousness, but these and an almost childlike sense of wonder are the prerequisites of the dedicated nature illustrator. When he holds in his hand the skeletal remains— the "test"—of a sea urchin, and examines them closely enough to see the intricate pattern left by the missing spines, he more than delights in the lavish beauty that is nature's way. And when he

considers that this small, gemlike object is one of the millions that litter the shore in some areas, he soon comes to realize the abundance with which nature has blessed our planet.

Though there are many people who specialize in a single phase of nature art, it is necessary that all, whether they are bird painters or botanical artists, have a basic foundation in drawing that enables them to portray the elements that constitute the picture as a whole. The versatile illustrator who can handle a wide variety of creatures well will naturally find his talents more in demand. If, in addition, he can master several techniques, such as opaque watercolor, pencil, pen-and-ink, scratchboard, and other mediums, so much the better. Publishers' budgets usually dictate whether color or black-and-white will be chosen for a given project. Black-and-white halftone or line is often preferred because it is a decidedly less expensive means of reproduction.

Happily, we are surrounded by a profusion of natural objects, all of which hold potential for paintings or illustrations. The creation of studies, full-color renderings of specimens, or complete habitat scenes composed in such a manner as to convey your love of this intrinsic natural beauty can all be roads to a most satisfying venture in art. If this book in any way assists you in finding that satisfaction and helps develop your awareness and observation, then we will have succeeded in opening for you the door to a world of form and elegance that otherwise might have gone unnoticed.

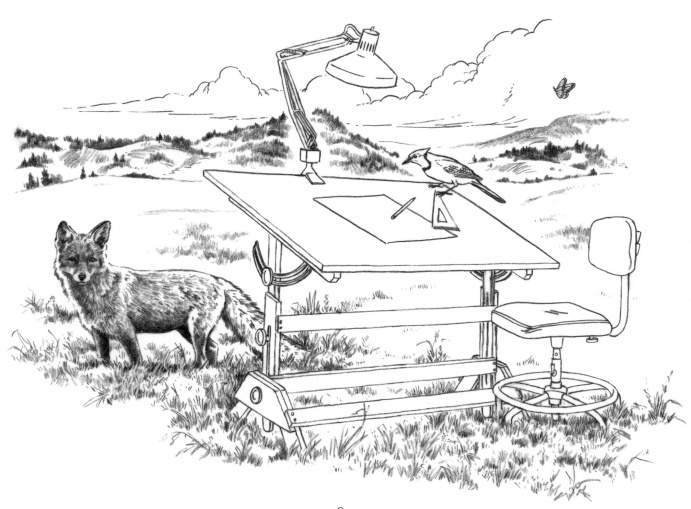

Illustrating
NATURE

MATERIALS
AND
EQUIPMENT

It is very difficult for the artist, whether he is a beginner or a professional, to walk into an art-supply store and not feel the excitement of being surrounded by tools that offer so many enticing possibilities. The colors gleam chromatically from glass counters; there are unused and coded pencils stacked in endless rows, little cases of steel-blue, silver, and gold pen nibs with their new black enameled penholders, row on row of colored inks, and pads of paper of every conceivable texture, hue, and size. Even the lowly eraser in its cardboard box has a special pristine dignity. Can we ever escape from this idyllic environment with only the things we truly need?

The needs of the nature illustrator could run the full gamut of art supplies, from simple pens and ink to complex oil paints complete with easel and other accoutrements. As you become more and more accomplished in one particular medium you will want to acquire everything needed in the way of materials in order to further your accomplishments. However, contrary to the fears of the beginner, all that is really necessary on the first lap of the journey are four new pencils—an H, an HB, a 2B and an 8H—a good 14″ × 17″ tracing pad, a spiral sketch pad, a kneaded eraser, and a pencil sharpener. The aim at the outset is to start

sketching and recording nature as you see it, for you are really just beginning to perceive the natural world anew and to make notes of what you observe.

PENCILS

One soon learns that pencils are graded from 9H to HB in a progressively numbered arrangement—9H, 8H, 7H, 6H, and so on—in descending order—and then from HB to 6B. The H's are all hard leads, with the highest number being the hardest pencil, and the B's are the soft leads, growing softer as the number gets higher. An H pencil is at the top of the hard-pencil pyramid—hard, but with an edge of softness—and HB, an excellent pencil for most purposes, is a medium lead—neither too soft nor too hard (see diagram). In doing a careful drawing, the use of an HB, F, or H pencil provides you with enough control to prevent smearing during the necessary trial-and-error changes without causing you to dig into the tracing paper or sketch pad, unless too much pressure is put on the pencil.

Ebony pencils or similar types are very black and very soft and make a perfect sketching pencil

for you to take with you when you go out in the field.

Another variety, known as the Wolff's carbon pencil, has much the same range of hardness as the ordinary pencil, but produces the look and texture of a charcoal drawing. It can be sharpened to a fine point in a pencil sharpener, and it is an easily controlled medium worthy of experiment. It also has the virtue of making the artwork look quite handsome when reproduced.

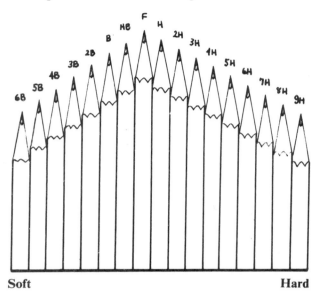

Soft **Hard**

PENCIL-CRAYON

Pencil-crayon is another medium that many people enjoy. It has the advantage of color but can be handled with the ease of a drawing pencil. There are several kinds to be found in the art-supply store. Prismacolor pencils come in a beautiful range of colors and are soft, allowing large areas to be covered without too much difficulty. The harder Mongol pencils have an entirely different texture but they also offer a large range of colors. They are much easier to sharpen in a pencil sharpener than the Prismacolor and can readily be used for fine detail. The pencil-crayon does not necessarily have to be confined to sketching; many excellent drawings with beautiful, intricate detail and strong color have been done in the past by professional artists who find the pencil-crayon a gratifying medium to work with.

PAPER

We have always used plain tracing paper for our preliminary sketches. A 9″ × 12″ or 14″ × 17″ tracing pad of ordinary art-store quality is economical, but the serious artist should acquire a vellum tracing pad of a similar size, to be used when completing final sketches. There will no doubt be problems to iron out in the rougher layout, and since the tracing vellum has a harder and less resilient surface that can withstand the physical abuse better than the common tracing paper, it is wise to use it for the final sketch. Why use two tracing papers? It is a matter of simple economics. Tracing vellum is a more expensive paper. To use it as a throwaway seems extravagant. Ordinary tracing paper, being much cheaper, is therefore more expendable. Tracing vellum also retains its dignity, so to speak, even when it has been passed from hand to hand and traced through several times. Another fine feature of tracing vellum is its ability to take ink. Its surface begs for pen lines of beautiful quality. It can be placed over an original sketch for inking if time becomes a problem, as it so often does. Reproduction of an inked drawing from vellum is not uncommon. Most printers do not object to finished art presented in this manner as long as it is mounted on a white heavyweight paper.

ILLUSTRATION BOARD

Since our work is usually for publication, we have as a general rule used illustration board for our final art. It is easy to handle and accepts whatever medium we choose, if we select the right surface. When bought in large 20″ × 30″ or 30″ × 40″ sheets, it can be cut to whatever dimensions are needed. Illustration board comes in two major surfaces. The term "hot pressed" is often used by manufacturers to denote a smooth surface. This rather high finish makes a perfect surface for pen-and-ink. The pen will easily skim across the surface of hot-pressed board, whereas it might have a tendency to catch on the medium- or rough-surfaced board classed as "cold pressed." The rougher-surfaced, more absorbent

cold-pressed boards are most often used for watercolor or gouache. When we "throw a wash," that the board is porous enough to accept the wash of color without having the wash lie on the surface and form puddles is of utmost importance. Of the rougher-surfaced boards, the medium finish is the one you are more likely to choose for color work if your aim is nature illustration. It allows you to paint the very finest of details without being hampered by the more pitted surface of an extremely rough board. However, if your technique has a tendency to be freer in concept, you might do well with the latter. As in all things concerning art, experimentation plays a large role in what you finally settle for in your personal equipment.

BRISTOL BOARD

There will be some occasions when illustration board will not fit the particular needs of the project you are working on. There are a goodly number of suitable papers, not the least of which are the bristol boards. These are not boards in the true sense of the word but, rather, finely surfaced papers. Of all the bristol board makers we have found that Strathmore produces the best paper for our purposes. This beautifully textured bristol board may be purchased in sheets that range from one-ply to five-ply. The "ply" is really a single sheet of paper. As each ply is added and laminated to the previous one, the bristol board becomes thicker. Strathmore is of unusually fine quality and it comes in both high- and medium-

finish (kid or vellum), but it grows progressively more expensive with each additional ply. A number of professionals use this kind of bristol board. Its many advantages include a durability under the stress of correction, an aspect discussed in more detail later on.

If you are just beginning to practice with pen-and-ink or with color, there are many brands of less expensive bristol-board pads that are available in any art store. The pad gives the beginner a more comfortable feeling; it is, in a sense, a statement in itself that if one drawing fails, there is more paper waiting, and somehow it is less disheartening to begin again. The surfaces of the bristol-board pads are not as finely textured as the Strathmore papers, but they are adequate.

One disadvantage of using color on bristol-board papers is that they have a tendency to buckle when wet because they are not firmly laminated to board. This can be disconcerting, as it will cause a puddling of washes even though the surface may be kid finish and therefore porous. It is wise for the artist with a commissioned color assignment to use illustration board to forestall this.

After a while, you will find that you will be able to recognize all the different textures and surfaces of papers and illustration boards, and will be able to choose the one that works best for you by fingertip touch.

PEN-AND-INK

If you lean toward black-and-white illustration, there is no more satisfying technique to begin with than pen-and-ink. The complexities of woodcuts, etchings, linoleum cuts, et cetera,

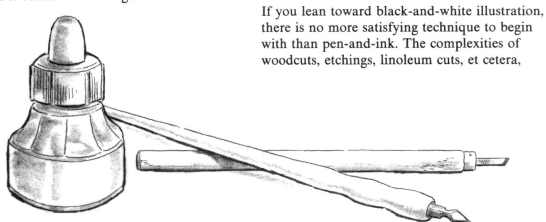

should be laid aside until mastery of the pen is well established. With the pen you can learn distribution of the dark and light content of a drawing, which is a prerequisite of all black-and-white art. Another factor to be taken into consideration is the economy of reproducing finished black-and-white art if it is for commercial use.

A number of waterproof black inks worth experimenting with are on the market. Along with these, many companies produce a wide range of colored inks. A beautiful drawing can be achieved by the use of a brown or sepia ink, but it might not have the qualities necessary for reproduction if a linecut were required by your client. The uniformity of color is sometimes uneven, and printer's plates made from your drawing would no doubt lose some of the most important detail. However, for the artist not concerned with reproduction, experimentation with colored inks might lead to very pleasant results.

In this age of exciting new devices we hesitate to say that we find it preferable to stay away from all mechanical pens in illustrating natural-science subjects, except for the technical demands of representing geological formations. Working with a quill pen may seem a trifle old-fashioned, but nothing expresses your artistic emotion better than that little nib, transmitting through your arm, just what you feel about line drawing. The mechanical pen has only one voice, so to speak, a straight, even, unvarying line. It is unequaled in its usefulness for mechanical drawing, but the nature illustrator has a story to tell of textures and roundness, and he often needs a varying line to express these qualities. Of course, this is a personal preference. The individual artist will determine where his own affinity lies. As in most things, trying different tools will bring forth your own likes and dislikes.

To start, we would recommend one small crow-quill penholder plus another larger, more versatile one (Gillott's, perhaps), along with a variety of flexible and nonflexible pen nibs, such as Gillott's mapping pens, long-shoulder crow quills, rigid extrafine pens, Hawk quills, to name just a few. The Osmiroid sketch pen is a very convenient fountain pen worth trying for outdoor sketching.

COLORS

The artist's palette for natural-science illustration very rarely strays from the colors of his subject matter. What liberty he is permitted is generally confined to background color. When working from specimens, the objective is to reproduce only the colors that nature has generously provided.

By and large, the palette is muted, and earth colors such as ochers, siennas, umbers, olive greens, sap green, and alizarin crimson come into use much more frequently than the more brilliant colors of the spectrum. Of course, there are exceptions to the rule, as in botanical and bird illustration.

We most often work with gouache or designer's colors. These offer an exquisite range of hues. Because they have such a finely ground pigment, they may be used either as a free watercolor wash or for dry-brush watercolor. This allows for a buildup of layers of color and thus for ultimate control. Winsor & Newton and Grumbacher have a full range of these colors; so do other manufacturers.

If you are just beginning to collect pigments we would like to suggest the following colors: alizarin crimson,* brilliant carmine, brilliant purple,* burnt or Chinese orange, burnt sienna,* cerulean blue, chromium oxide green, cobalt blue,* deep or burnt umber,* flame red or vermilion,* deep green,* light green, medium green,* lemon yellow,* mountain violet, olive green,* orange,* raw sienna,* raw umber,* sepia, turquoise blue

deep,* yellow deep,* yellow light, and yellow ocher.* You should have a good permanent white and a tube of ivory black or jet black as constant members of the paint box, and possibly an additional tube or jar of a nonbleeding white that could be used for correction, should the need arise. A similar palette is suitable for oils.

Gouache or designer's colors are admittedly on the expensive side and have a disconcerting habit of drying in the tube. To extend their life a bit, it might be helpful to find a tightly lidded tin box to keep them in. It might be helpful, too, in order to avoid having the tube caps dry on the tubes to smear a bit of Vaseline on the threads as a lubricant before you cap the paints. Colors such as Hooker's green and Hooker's green light watercolor added to the above list will prove invaluable for painting foliage and can readily be mixed with designer's colors. If expense is a consideration, the list can include only the colors marked with asterisks as the nucleus of the full set that you eventually will have. As you move along to new and varied projects, there is little doubt that colors will be added to meet the specific needs of that work, or even to suit your experimental fancy.

PALETTES

The best palette for laying out gouache or designer's colors is a plain white porcelain tile. This is sometimes a rare commodity in art stores, but is well worth the effort to try to obtain one. Plastic palettes with wells and compartments are more easy to come by and very useful at times, but certain colors have a tendency to stain them permanently. A porcelain tile or compartmentalized tray will wash absolutely clean.

BRUSHES

An artist's tools are the most valued possessions in his studio. It is all very well to believe that the "real" artist can work with any kind of brush or paint or drawing paper, but this notion is for the most part myth. A fine set of brushes, of the best quality that can be afforded, are as necessary in the studio as a surgeon's instruments are in the operating room. Brushes whose hairs fall out or split apart for no apparent reason should be avoided. It simply does not make good sense to attempt to work with an inferior tool when your full concentration should be applied to the painting at hand. Winsor & Newton, Grumbacher, and Simmons are our favorite brush makers. We have long enjoyed using the Series 7 watercolor brushes of Winsor & Newton, and have had excellent service from all we have ever owned. Winsor & Newton also produce a slightly less expensive brush, the Series 707, that has proved quite satisfactory. For nature illustration we would recommend #00, #0, #1, and (for larger areas) #2 brush. Most art stores carry better-quality small sable brushes that come to a fine point, and those are what to look for. The clerk will usually provide a jar of water so that you can test your intended purchase. Wet the brush thoroughly and shake it. The hairs should form a single symmetrically even point with just that one quick shake of the wrist. If, however, the hairs separate or there is a long central hair or two, either go through the process again to give the brush another chance (sometimes new brushes have resinous material on them that the initial wetting does not remove) or discard it and go on trying brushes until you find one that is up to standard. The brush is one of the most important items on your list of supplies, and though the prices may seem high, in the long run a good one will be worth all you invested in it.

FIXATIVES

Workable fixative, a useful item in the studio, can be used to "fix" pencil sketches as well as to isolate background colors and keep them from "bleeding" through any additional painting. Be careful not to spray too heavily, as this might cause the surface to become too slick to hold the additional color. Myston, a Grumbacher product, is one spray fixative that can be used in this way. It will also protect the finished painting and lightly intensify the colors.

MISCELLANY

You will find that it is often the small things that are significant in the art studio. Kneaded erasers are a must. The often used gum eraser has little place in the field of illustration. It leaves bits of shavings on a drawing that can be very hazardous. Some positive means of getting rid of its residue is required, and the artist cannot afford possible accidents, such as smears or color loss, because of its use. A kneaded eraser, on the other hand, can be manipulated into different shapes that help the artist to erase a very small area as easily as a larger one, and it can be comfortably employed for general cleanup on a finished piece of artwork.

Along with a steel-edged ruler and a small set of transparent triangles and curves, you will want a proportional divider. This last could be your most expensive investment, but every studio that deals in nature art should have one as a permanent resident. It is a simple measuring device that helps preclude errors in proportion that we may sometimes overlook in an otherwise accurate drawing. Any reliable art-supply store will have a variety of such dividers for you to choose from in order to fit your budget.

Masking tape, a mainstay in every studio, can be both an asset and a hazard. There are many masking tapes that do not stick to the sur-

face of the board or paper for a long period of time. Scotch drafting tape is designed to temporarily hold a sketch to paper or illustration board without lifting bits of the surface when it is removed. The use of sticky cellophane tape should be avoided at all costs because, when the tape is lifted, there is an almost inevitable destruction of the surface.

You will find that your collection of small accessories is augmented nearly every time you visit the art-supply store. There are many intriguing aids to the artist, and it is usually trial and error that stocks the well-organized studio over a period of years.

The studio itself can be a corner of your own somewhere in your home or a large room set aside for that purpose. A good adjustable artist's drawing table that can be set in a horizontal position for more complete leverage when drawing, a comfortable chair to sit the long hours away, and good fluorescent lighting are the only basic requirements. Some library space might be an asset, as you will no doubt begin to collect photos and books to expand your knowledge of natural history as well as your technique.

Of the many products on the market, it seems worthwhile to stick with name brands that have been with us for a long time, but this should not stop you from trying new products that come into the art-supply store from time to time.

TRICKS OF THE TRADE

More years ago than we care to admit we came to the illustration "business," in complete innocence. The studios of other artists, we thought, were

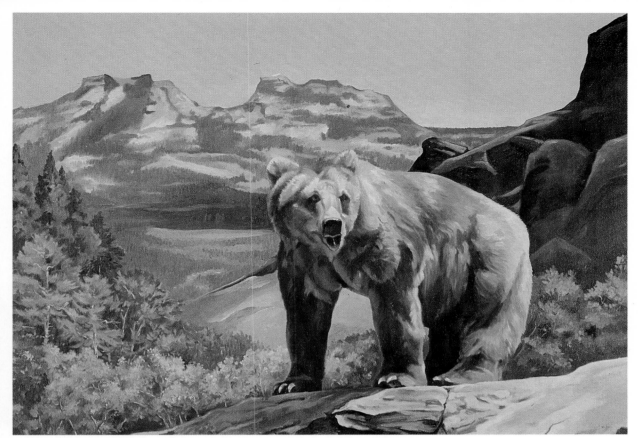

Plate 1. American grizzly bear (*Ursus horribilis*). Oils. Dorothea Barlowe.

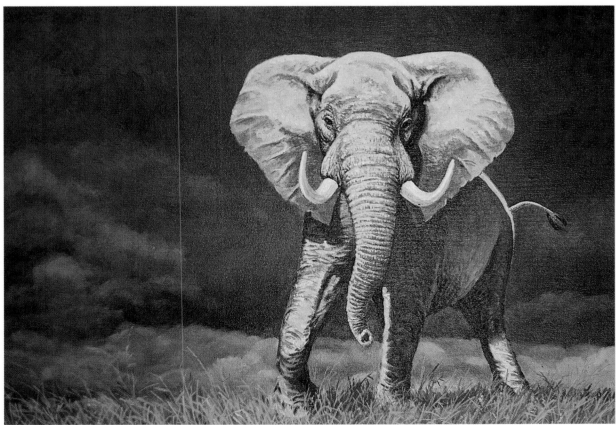

Plate 2. African elephant (*Loxodonta africana*). Casein. Sy Barlowe.

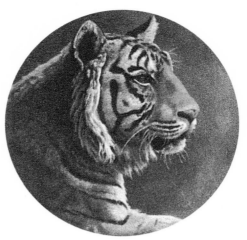

Plate 3. Head of a Bengal tiger (*Panthera tigris tigris*). Detail of frontispiece. Gouache. Sy Barlowe.

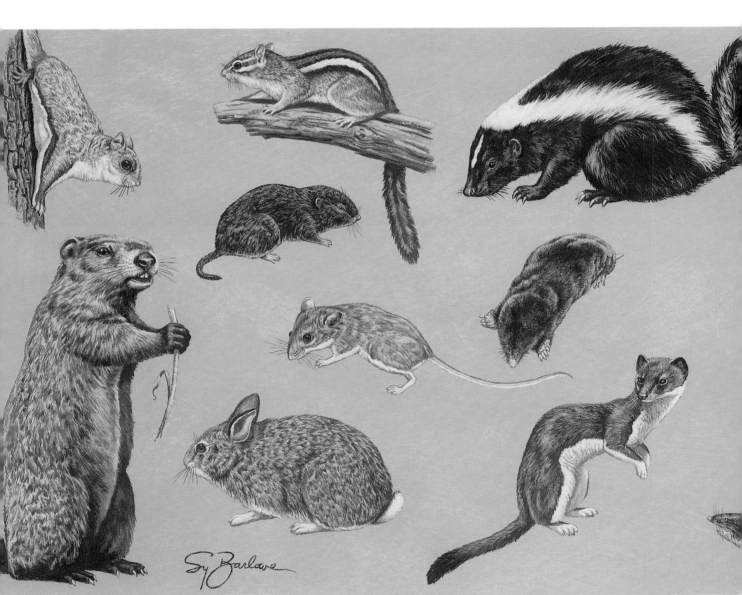

Plate 4. "Survivors in Suburbia." Acrylics and gouache. Sy Barlowe.

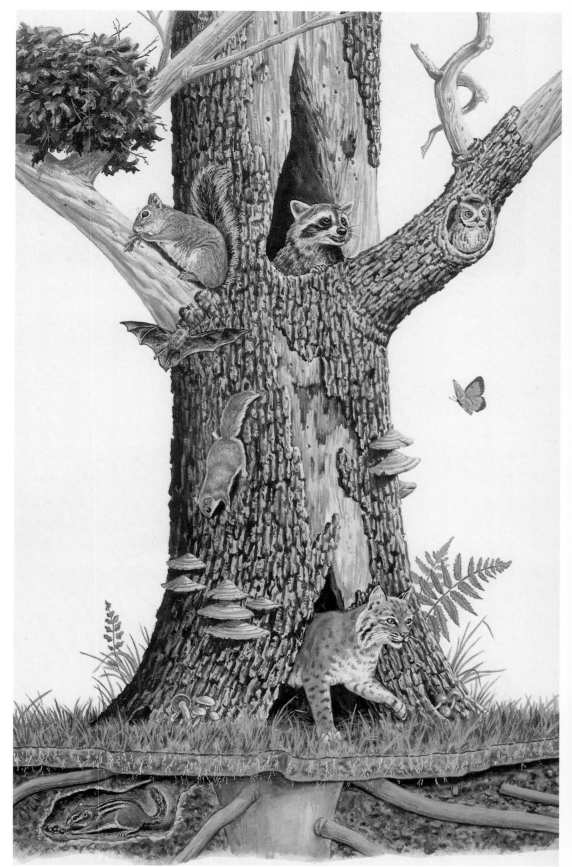

Plate 5. "Life in a Dead Tree." Gouache. Sy Barlowe.

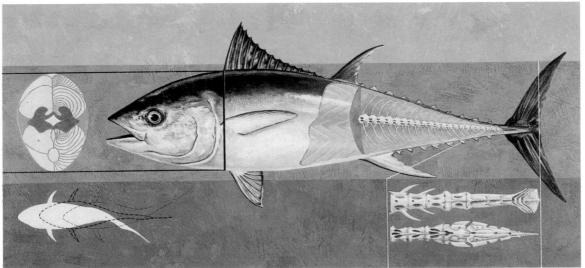

Plate 6. Bluefin tuna (*Thunnus thynnus*). Gouache. Sy Barlowe.

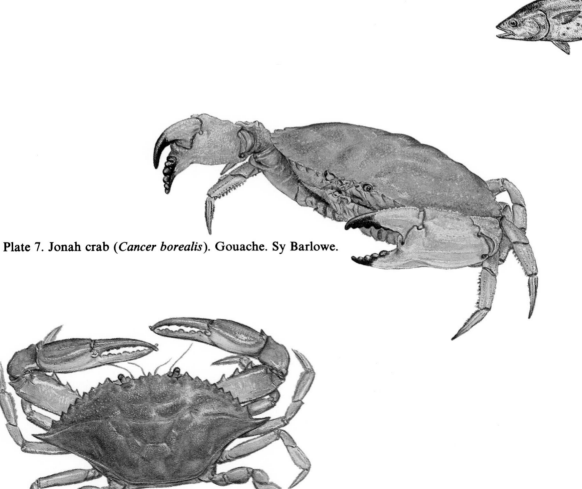

Plate 7. Jonah crab (*Cancer borealis*). Gouache. Sy Barlowe.

Plate 8. Blue crab (*Callinectes sapidus*). Sy Barlowe.

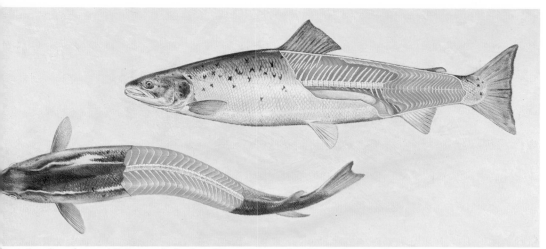

9. Atlantic salmon (*Salmo salar*). Acrylic and gouache. Dorothea Barlowe.

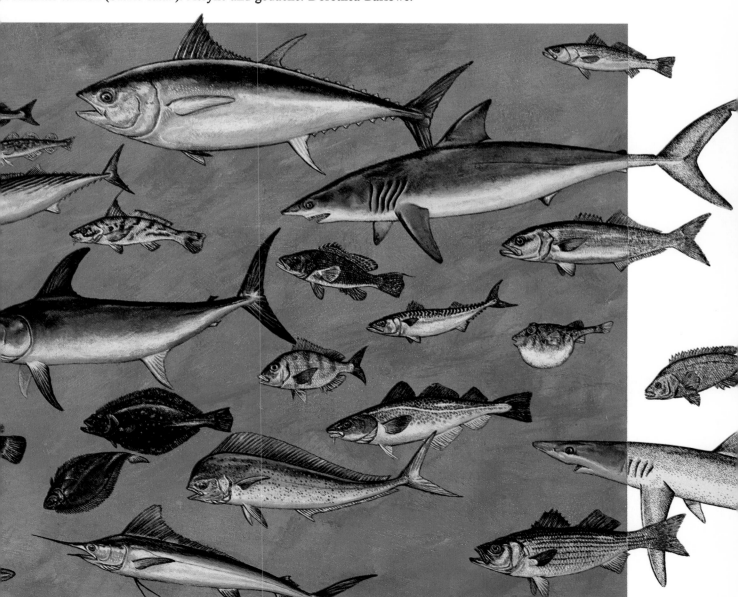

Plate 10. "The Fish Around Us." Acrylics and gouache. Sy Barlowe.

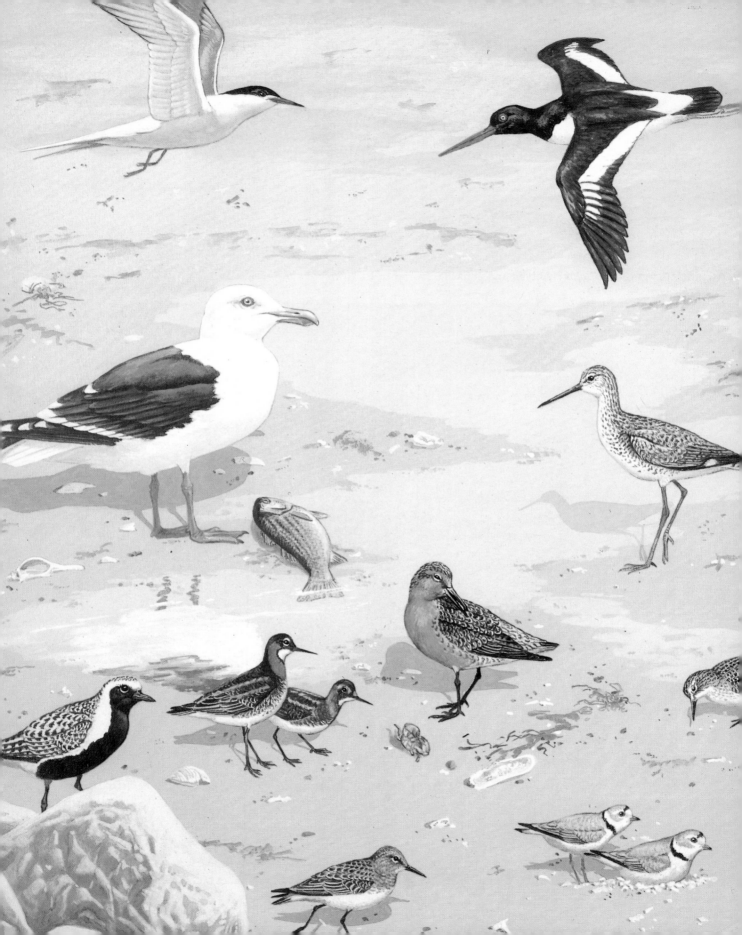

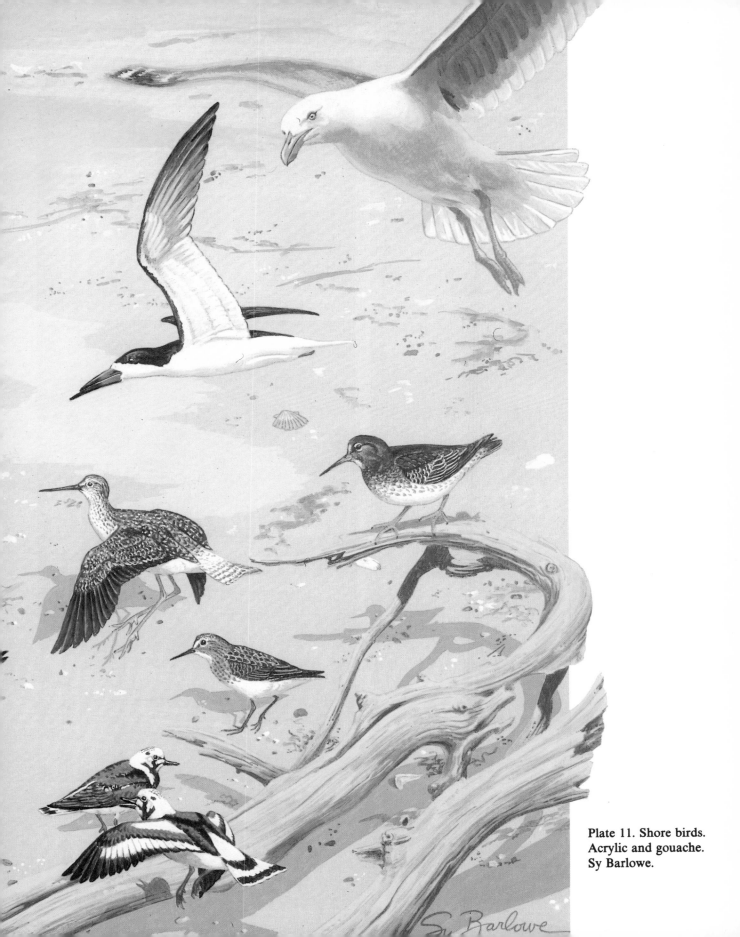

Plate 11. Shore birds.
Acrylic and gouache.
Sy Barlowe.

Plate 12. Indian peahen (*Paro cristatus*).
Pastels. Dorothea Barlowe.

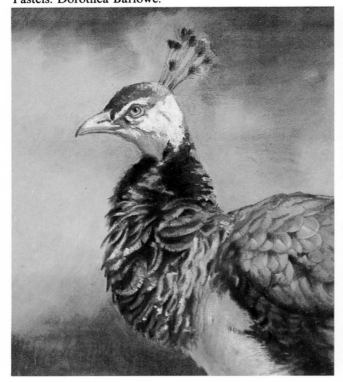

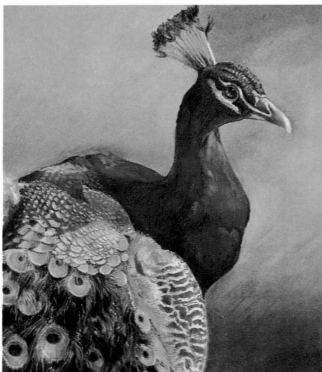

Plate 13. Indian peacock (*Paro cristatus*).
Pastels. Dorothea Barlowe.

Plate 14. Toucan (family Ramphastidae).
Pastels. Dorothea Barlowe.

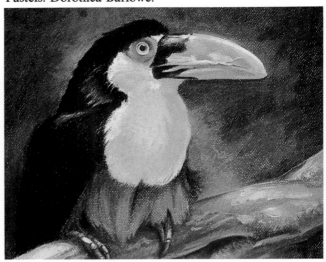

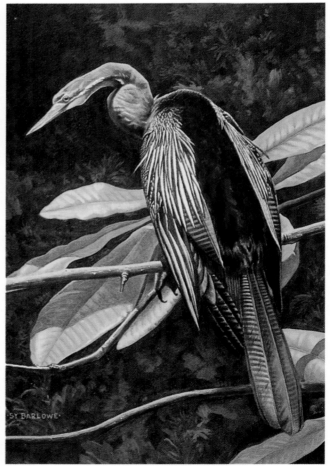

Plate 15. Female anhinga (*Anhinga anhinga*).
Gouache. Sy Barlowe.

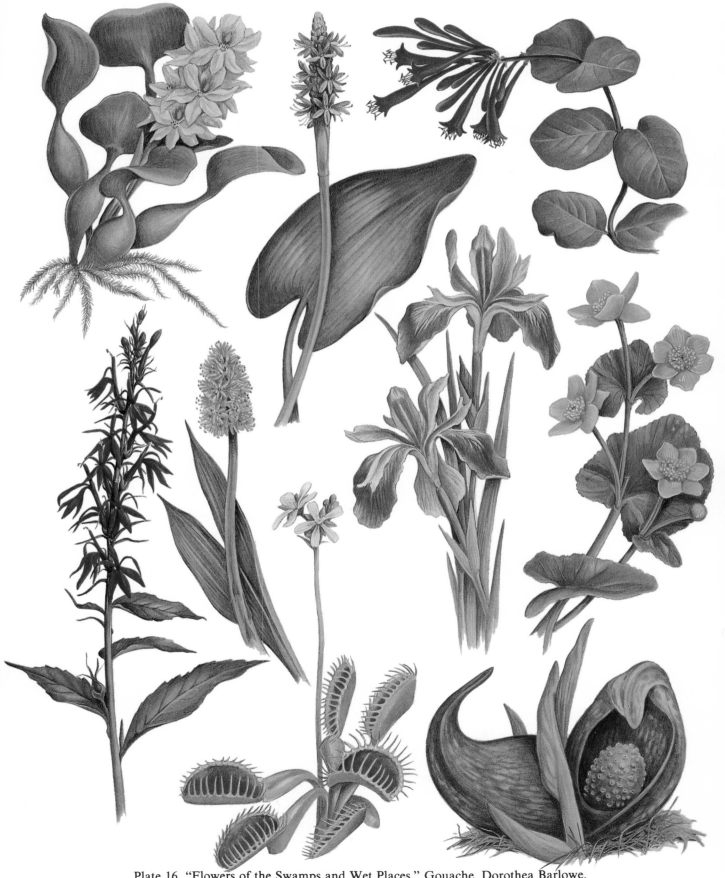

Plate 16. "Flowers of the Swamps and Wet Places." Gouache. Dorothea Barlowe.

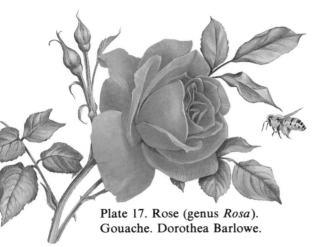

Plate 17. Rose (genus *Rosa*).
Gouache. Dorothea Barlowe.

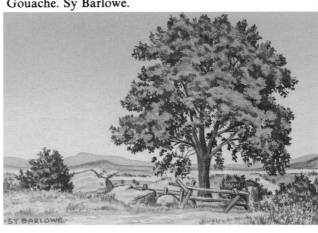

Plate 18. Sugar maple (*Acer saccharum*).
Gouache. Sy Barlowe.

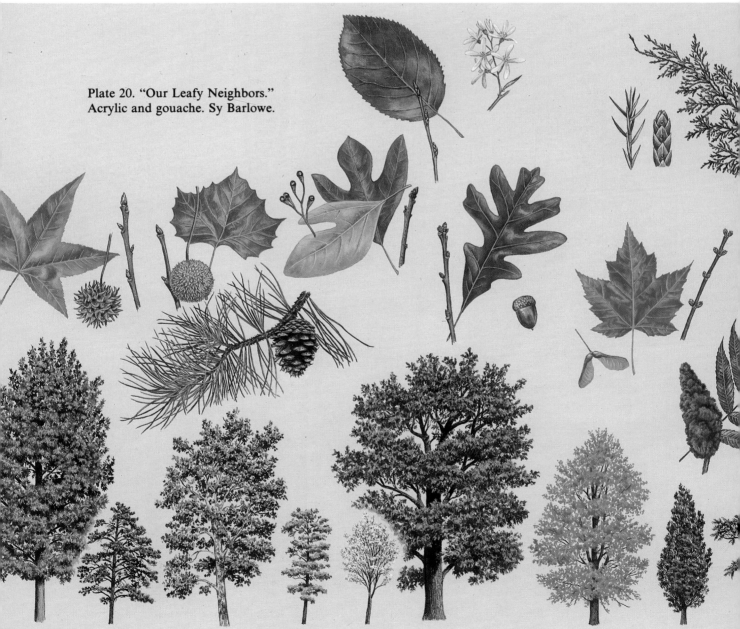

Plate 20. "Our Leafy Neighbors."
Acrylic and gouache. Sy Barlowe.

Plate 19. Ponderosa pine (*Pinus ponderosa*).
Gouache. Sy Barlowe.

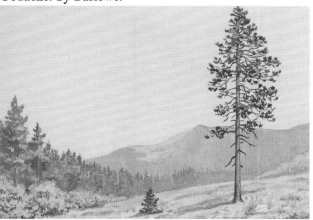

Plate 21. Fruit and blossoms of the hawthorn and plum.
Gouache. Dorothea Barlowe.

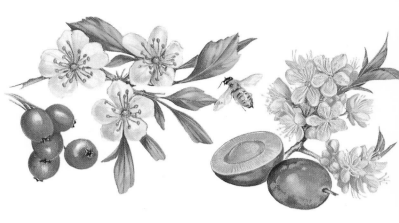

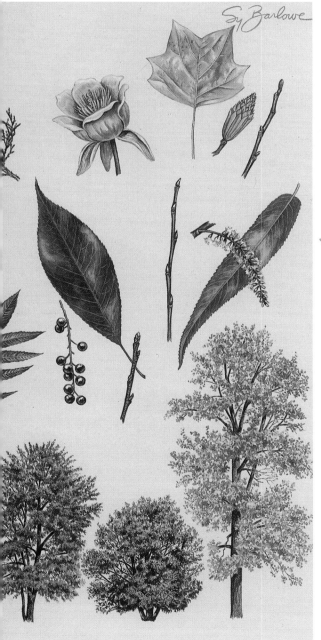

Plate 22. Day lilies (*Hemerocallis*).
Gouache. Dorothea Barlowe.

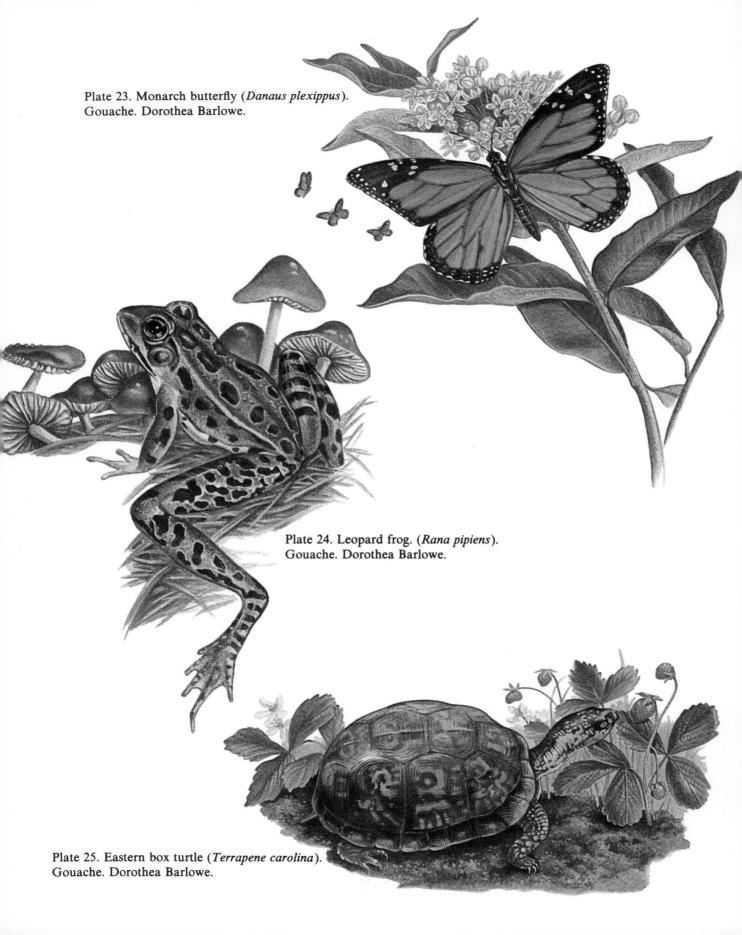

Plate 23. Monarch butterfly (*Danaus plexippus*).
Gouache. Dorothea Barlowe.

Plate 24. Leopard frog. (*Rana pipiens*).
Gouache. Dorothea Barlowe.

Plate 25. Eastern box turtle (*Terrapene carolina*).
Gouache. Dorothea Barlowe.

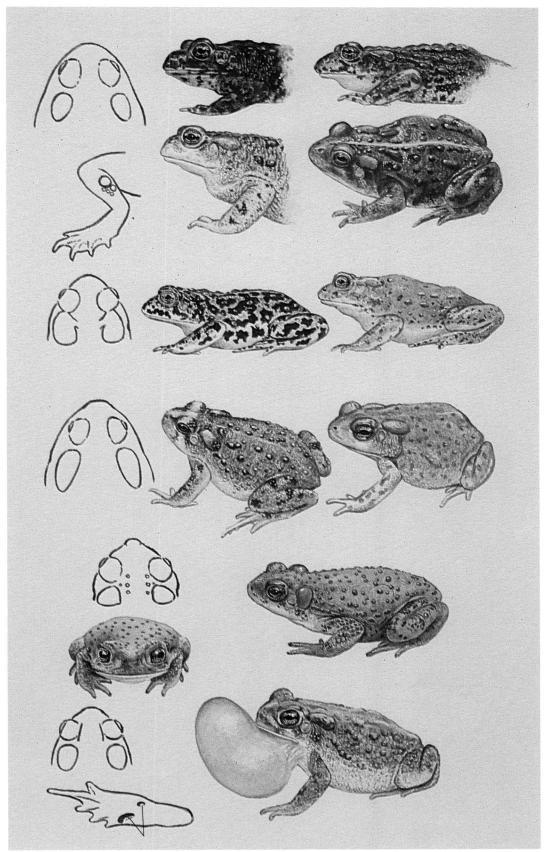

Plate 26. Ten species of toads. Gouache. Sy Barlowe.

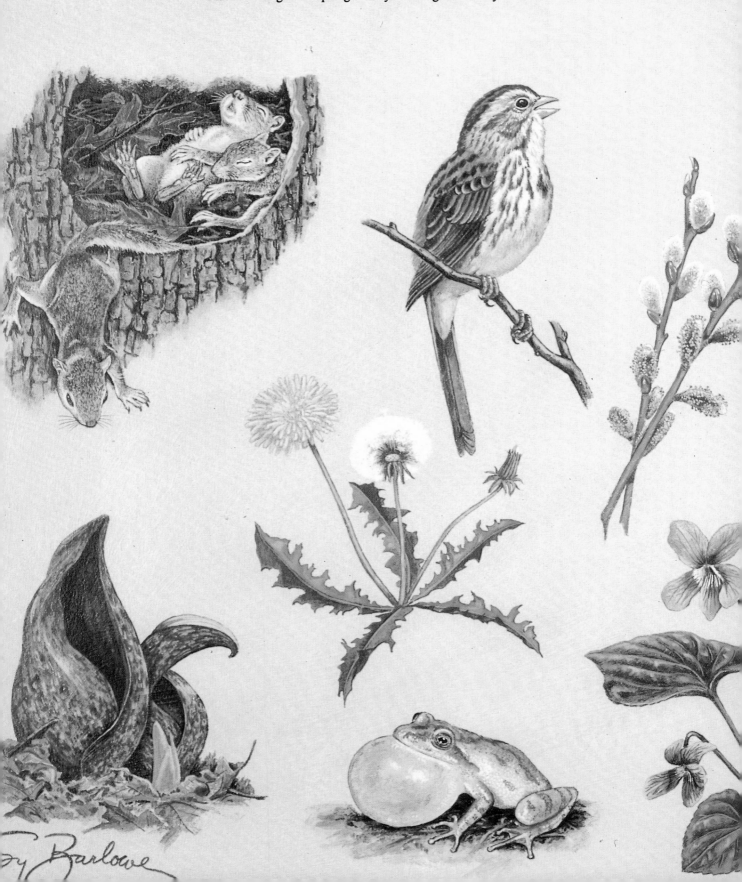

Plate 27. "Signs of Spring." Acrylic and gouache. Sy Barlowe.

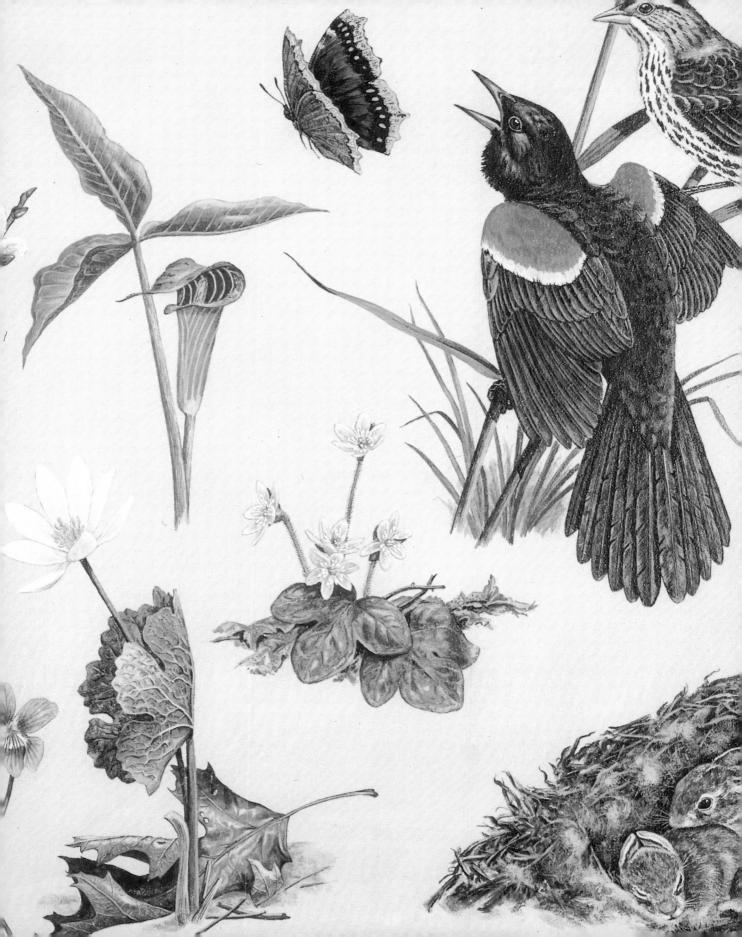

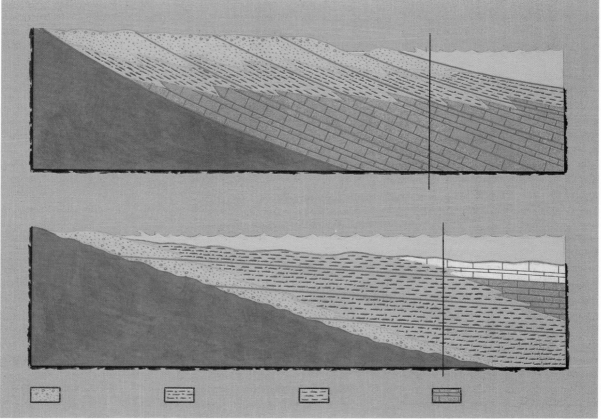

Plate 28. Geological strata. Gouache. Sy Barlowe.

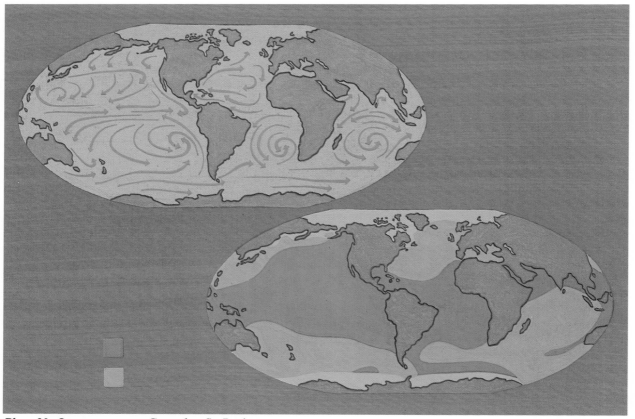

Plate 29. Ocean currents. Gouache. Sy Barlowe.

noble edifices where the illustrations rolled off the drawing boards in an unfrenzied pattern of high-minded thinking. Not so. The artist is a hard-working individual, and professional-looking art is the result of long hours of work, study, and patience spiced with a dash of the tricks of the trade.

In time you will learn, as we did, how to get rid of an annoying color spill on an otherwise pristine surface, how to keep sweat stains off an illustration board, and so on. You will no doubt add many shortcuts as you go along, but to give you an edge on the whole matter we list here a few helpful hints, the most important of which is the following observation:

There are very few pieces of work that are unsalvageable. A good retouch white can save almost anything.

To protect your work as you go along, always work with a small piece of tracing paper or scrap paper under your right hand. If your habit is to hold the board with your left hand as well, tape a piece of paper along the left-hand margin

of your work. This precludes the accumulation of hand stains, which can make the surface of the board too slick and your work unsightly.

Clean all brushes thoroughly after your work, regardless of the medium you are working in. Brushes are expensive, and caked paint or ink can ruin the quality of sable hair.

When a page is to have more than one "spot" illustration on it, cover the entire surface of the board with a clean sheet of tracing paper, tape the paper in place, and cut or tear away just enough of it to allow you to work on one individual illustration at a time. This keeps all other areas and tracings from smearing or staining.

With patience, an ordinary liquid household bleach such as Clorox can be used to blot up a color stain on a finished piece of artwork. Brush the bleach on with an old brush, wait a few minutes, and blot with facial tissue. Repeat until the stain is gone.

On pen-and-ink drawings, a fresh, new single-edged razor blade held in a completely horizontal position, blade side down, can be used to scrape an ink blot or slight error off a slick-surfaced illustration board. Then place a small piece of tracing paper over the resulting roughened area and burnish it with a smooth-edged coin to help restore the illustration board to its original finish.

If a clean margin is required next to a painted area on the illustration board, draw a penciled outline around the area, cut strips of masking tape, and tape the strips along the outline to act as a retainer for the color. This will enable you to paint the area unhindered by the fear that your edges will be uneven.

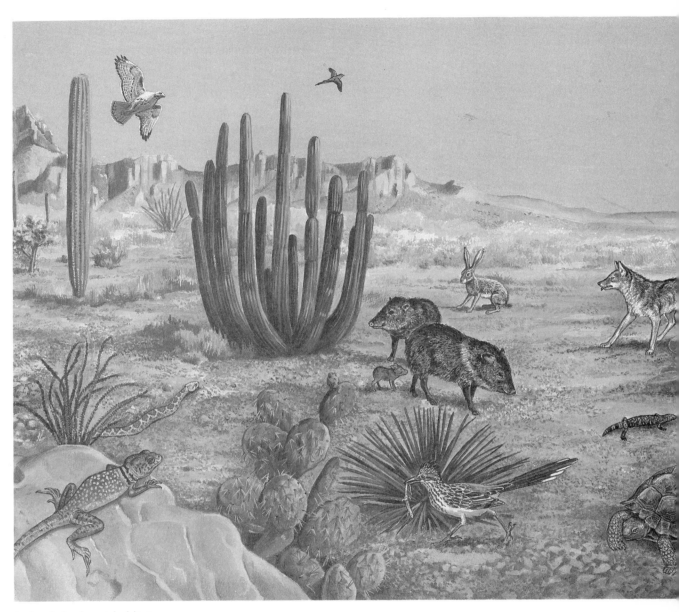

Animals in desert habitat

ANIMALS

Anthropologists are uncertain why some of our primitive ancestors mixed bear grease with red ocher and set about decorating the dimly lit interior of the caves of Lascaux and Altamira. The results, as we know, are some of the most spirited animal paintings that have ever existed. Our first animal illustrators may have created their work for purely religious reasons, or they may simply have wished to capture in some way the fluid lines and grace of the abundant animal life around them, thus preserving it forever. Their reasons we can only conjecture, but the legacy is left for us to enjoy. The paintings remain as fresh in concept as any done in the twentieth century. Perhaps one of the lessons we can learn from our progenitors is that in order to adequately represent the grace of movement in an animal, we must know the creature extremely well. In this modern world we do not have the access or the time to observe animals in the same manner as our ancestors, but we can make up for this by studying every facet of animal anatomy and environment in order to help us express the spark that ignites our own inspiration.

The task of drawing a completely accurate representation of an animal is a worthy challenge. Once you know what an animal is like physically—the manner in which it moves, what makes it special for its kind, even how it survives—then you can depict it in any suitable environment. What we want most as artists is to be able to render a painting or drawing that says all there is to say about the subject we have chosen. Small details in the individual species—the lift of the head, the expression in the eyes, the texture of the fur, the differences of patterns—all lend to our final work a satisfying, realistic quality.

One of the most important experiences you can have is working from live animals. A day or two spent sketching at the zoo or local natural-history museum every so often can be of very great value. If you have a camera to go along with your sketching equipment, you can gather

the further reward of a collection of animal photographs to file away for future use. Those of you who are fortunate enough to live in the country should add to your personal files pictures of forest scenes, meadows, ponds, and all kinds of plant closeups for background settings. These could save you hours of hunting once you have begun to do battle with preliminary sketches. Of course, discretion dictates that the animal be placed in the proper environment. It just wouldn't do to use temperate-zone vegetation behind an African lion, or desert plants behind a white-tailed, or Virginia, deer. A moderate amount of research in the nearest encyclopedia should set you on the right path.

Sketching animals at every opportunity is really the key to becoming the best animal artist you are capable of being. If a pet dog or cat is available, quick sketches to capture the position of a stretching cat or detailed drawings of a dog's eyes or foot and leg postures will give you substantial information that will be useful should you decide to do an illustration of one of their wilder cousins.

Structurally, the small domestic cat's skeleton is much the same as that of the big cats. Their claws function in the same way, they move in the same supple, majestic way as a lion or leopard, and their eyes have very similar characteristics. To know your cat is truly to know the whole feline tribe. The same holds true of other

family groups. Certainly, there are obvious differences, but basically the skeletal structure is so much the same that a big German shepherd dog or Alaskan husky, for example, can be a model for the position of a timber wolf. The addition of facial expression, fur texture, coloring, and a general knowledge of wolves derived from your own sketches and notes will surely produce the image your illustration requires.

In the following pages, there are notes on the anatomy of the major families, detail studies to work from, and discussion of varying techniques for rendering a final drawing. However, it will be your own perseverance, observation, and dedicated work that will determine how far you can go.

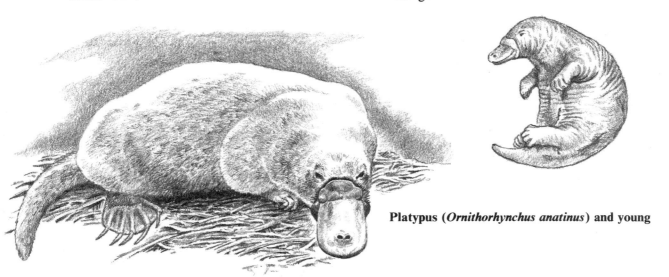

Platypus (*Ornithorhynchus anatinus*) and young

20

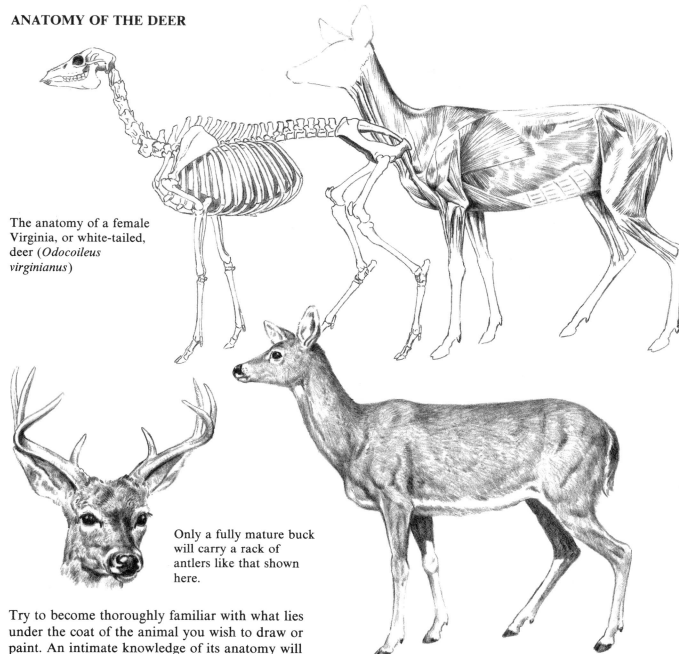

The anatomy of a female Virginia, or white-tailed, deer (*Odocoileus virginianus*)

Only a fully mature buck will carry a rack of antlers like that shown here.

Try to become thoroughly familiar with what lies under the coat of the animal you wish to draw or paint. An intimate knowledge of its anatomy will give the drawing the convincing solidity such a representation requires. Bone structure and musculature play definite roles in how an animal moves. Experiment with making a group of careful drawings of the skeleton, then of the muscles that lie over it, and finally of the completed deer. This kind of early learning process will lead to a far better understanding of the structural relationships of your subject. It is not necessary to repeat this every time you wish to produce a drawing, but if you do run into difficulty, it may be wise to refer back to the anatomy to try to iron out whatever problem seems to have arisen.

The Virginia, or white-tailed, deer (*Odocoileus virginianus*) is a member of a broad, loose association of orders whose scientific designation is Ungulata, and which includes all hoofed mammals. These are the grass and plant eaters, and

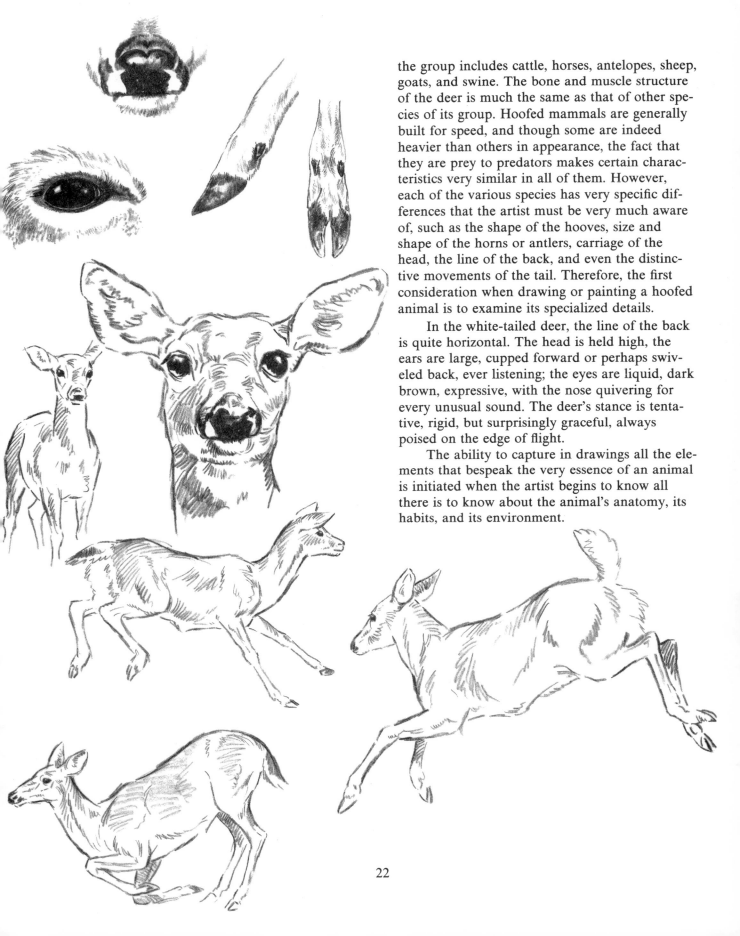

the group includes cattle, horses, antelopes, sheep, goats, and swine. The bone and muscle structure of the deer is much the same as that of other species of its group. Hoofed mammals are generally built for speed, and though some are indeed heavier than others in appearance, the fact that they are prey to predators makes certain characteristics very similar in all of them. However, each of the various species has very specific differences that the artist must be very much aware of, such as the shape of the hooves, size and shape of the horns or antlers, carriage of the head, the line of the back, and even the distinctive movements of the tail. Therefore, the first consideration when drawing or painting a hoofed animal is to examine its specialized details.

In the white-tailed deer, the line of the back is quite horizontal. The head is held high, the ears are large, cupped forward or perhaps swiveled back, ever listening; the eyes are liquid, dark brown, expressive, with the nose quivering for every unusual sound. The deer's stance is tentative, rigid, but surprisingly graceful, always poised on the edge of flight.

The ability to capture in drawings all the elements that bespeak the very essence of an animal is initiated when the artist begins to know all there is to know about the animal's anatomy, its habits, and its environment.

22

ANATOMY OF THE WOLF

We have chosen the timber wolf (*Canis lupis*) rather than a dog as an example of the family Canidae because as nature artists we are most often called upon to portray animals in the wild. The family includes wolves and foxes as well as dogs, both wild and domestic.

There seems to be little doubt in the minds of scientists that the wolf and dog spring from a common ancestry. Their teeth, bone structure, and musculature are remarkably similar, and it is only through man's manipulation that extreme physical variability has been developed in our domestic house pets. The collie, German shepherd, and husky still retain many of the characteristics of the wolf, such as the upright ears, the deep-chested body structure, the fully furred tail, and the formidable array of teeth.

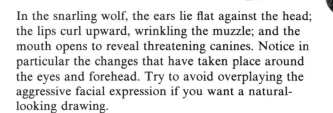

In the snarling wolf, the ears lie flat against the head; the lips curl upward, wrinkling the muzzle; and the mouth opens to reveal threatening canines. Notice in particular the changes that have taken place around the eyes and forehead. Try to avoid overplaying the aggressive facial expression if you want a natural-looking drawing.

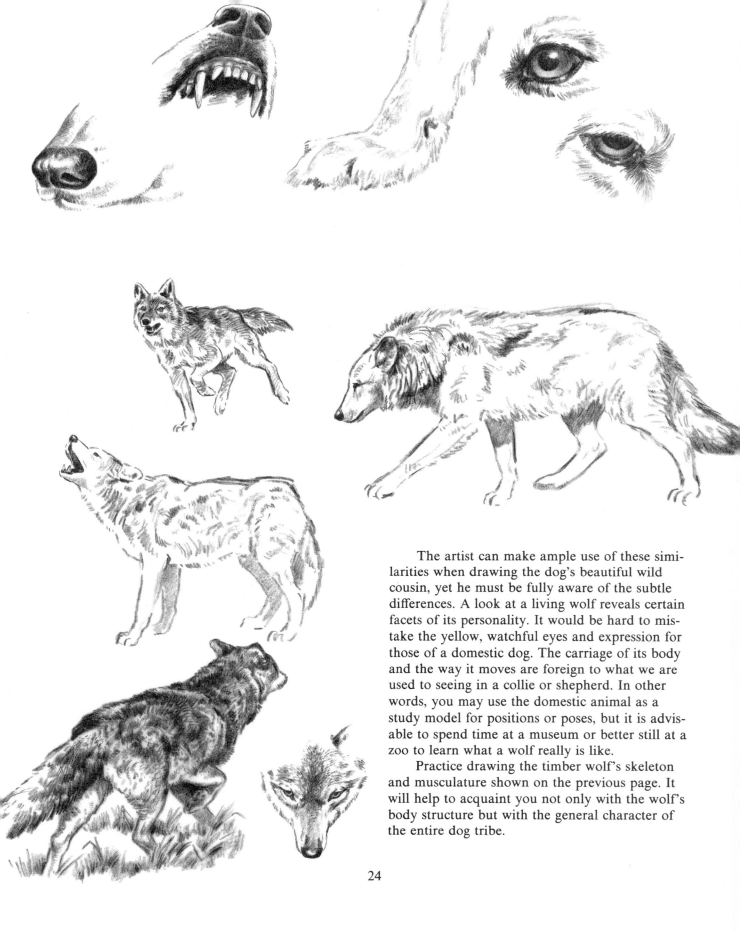

The artist can make ample use of these similarities when drawing the dog's beautiful wild cousin, yet he must be fully aware of the subtle differences. A look at a living wolf reveals certain facets of its personality. It would be hard to mistake the yellow, watchful eyes and expression for those of a domestic dog. The carriage of its body and the way it moves are foreign to what we are used to seeing in a collie or shepherd. In other words, you may use the domestic animal as a study model for positions or poses, but it is advisable to spend time at a museum or better still at a zoo to learn what a wolf really is like.

Practice drawing the timber wolf's skeleton and musculature shown on the previous page. It will help to acquaint you not only with the wolf's body structure but with the general character of the entire dog tribe.

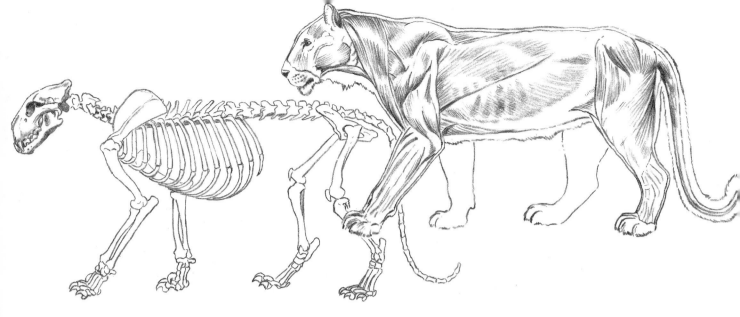

ANATOMY OF THE TIGER

Few of us have had the awesome privilege of seeing a tiger in its wild state. Undisputed master of whatever terrain it inhabits, this magnificent carnivore is a prime example of the cat family. It moves with the grace that all cats exhibit, without exception, from the largest to the smallest, and the members of the cat tribe are numerous. The tiger (*Panthera tigris*) alone has seven different members of its species, the grandest and most heavily furred being the Siberian tiger (*Panthera tigris altaica*). Just seeing one of these rare beauties in the zoo is enough to fire the imagination of any artist interested in drawing animals.

The large family of cats, classified as Felidae, provides the artist with some of the most spectacular subject matter in the animal kingdom. Cats can be spotted, striped, streaked, or solid in color. There are black, melanistic specimens of jaguar and leopard whose velvety pelage when seen from certain angles reveals spots like those of their naturally colored littermates.

Though cats vary greatly in coat color and pattern, underneath their rippling pelts the basic skeleton and muscle structure are precisely the same. Once again, it would be advisable to thoroughly familiarize yourself with the anatomy

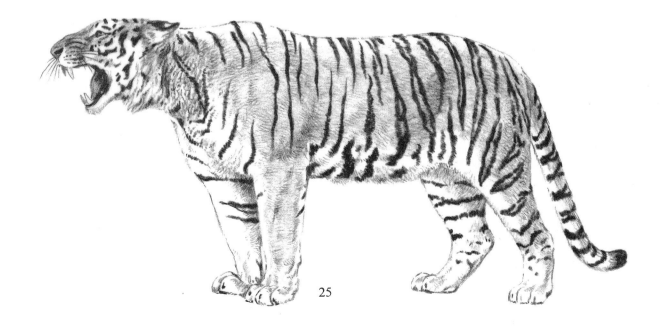

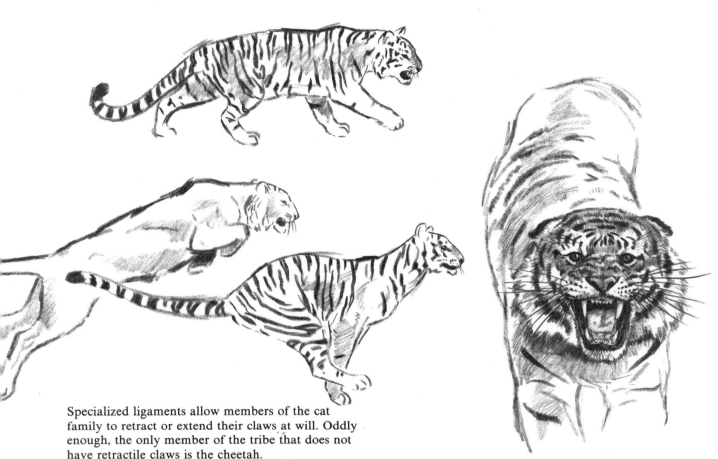

Specialized ligaments allow members of the cat family to retract or extend their claws at will. Oddly enough, the only member of the tribe that does not have retractile claws is the cheetah.

Claw withdrawn **Claw extended**

of tigers. They have retractable claws designed to seize and hold prey, and the pupils of the eyes are vertical slits that widen and narrow under changing conditions of stress or lighting; other physical characteristics include expressive whiskers and ears, as well as a roughened tongue within jaws that support impressive canines.

It has been said that "God created the Cat so that men could caress the Tiger." To artists fortunate enough to have a cat as a house pet, the truth of this statement takes on an even greater significance. Every movement and attitude so often seen in Tabby is just a scaled-down version

of what any of the larger, more formidable cats can do. Study him, sketch him, and apply this handy knowledge to your drawings of his larger cousins. However, with or without your own personal "tiger," some hours spent at the museum or zoo watching or sketching the big cats can be a positive step in making your drawings or paintings ring with authenticity.

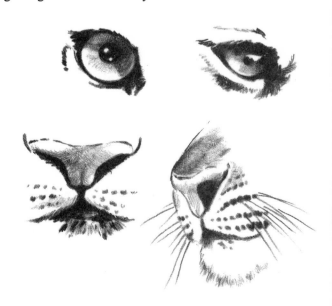

26

ANATOMY COMPARED

To summarize the three anatomical vignettes on the previous pages, we have brought together both the domestic and the wild animal. When they are seen side by side, it becomes evident how alike in structure they are. Basically, their inner anatomy is similar. But outwardly, after all, a tiger is not a house cat, a deer is not a roan antelope, and a dog is not a wolf. Though they are bone-for-bone counterparts (and we need to know this for the sake of artistic integrity), it is the outward appearance that we are ultimately concerned with. As artists, we must be ever alert to the differences that define the animal we are working with, and the eye must become accustomed to seeing whatever small nuance provides those differences. Many times we are dealing with subspecies in addition to the main species. Therefore, minute details such as head shape, set of the eyes, or color pattern can be of great importance.

Keeping a sketchbook handy on your next trip to the zoo or museum for quick sketches and color notes will do a lot to advance your ability to perceive the subtle physical traits that distinguish not only species from species, but species from subspecies.

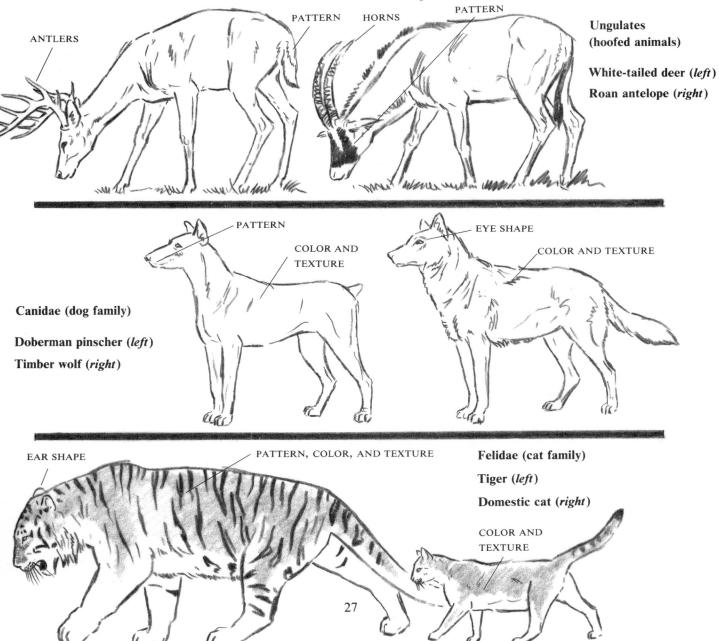

ANTLERS

PATTERN

HORNS

PATTERN

Ungulates (hoofed animals)

White-tailed deer (*left*)

Roan antelope (*right*)

PATTERN

COLOR AND TEXTURE

EYE SHAPE

COLOR AND TEXTURE

Canidae (dog family)

Doberman pinscher (*left*)

Timber wolf (*right*)

EAR SHAPE

PATTERN, COLOR, AND TEXTURE

Felidae (cat family)

Tiger (*left*)

Domestic cat (*right*)

COLOR AND TEXTURE

27

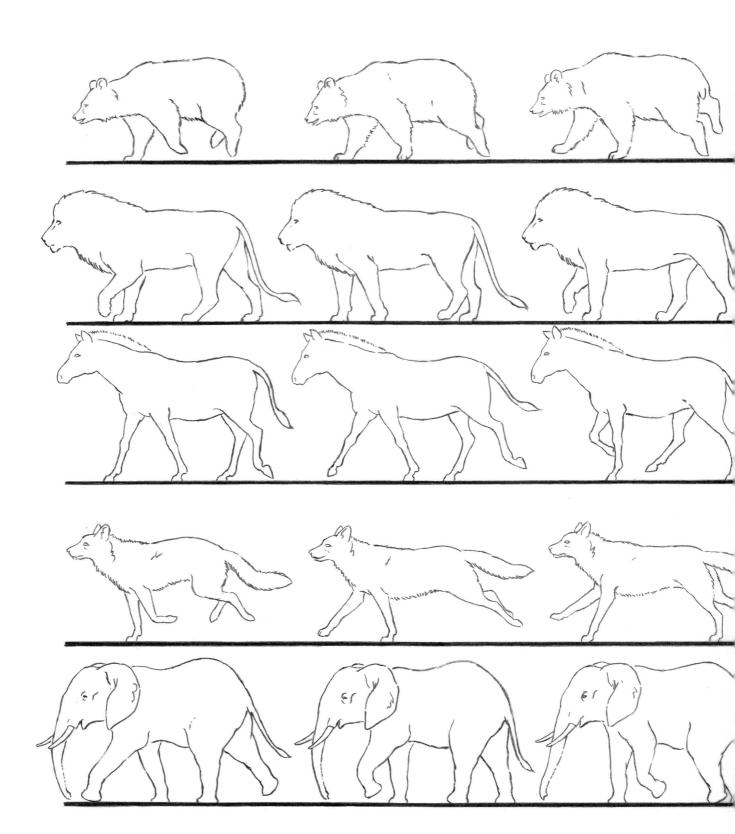

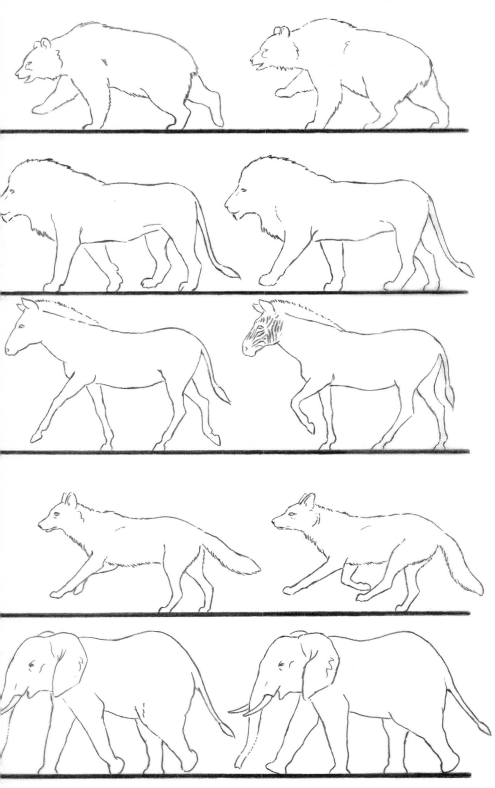

ANIMALS IN ACTION

There are times when you may be called upon to build a composition around an animal in motion. Whether it is walking, running, or galloping, each has a way of moving that is characteristic of its species and dictated by its anatomy.

Your photo file should provide you with action pictures of various animals, but any one of the moving animals on these pages is a good basis for a fully rendered drawing. A simple practice exercise is to choose a photograph that approximates one of the positions and work to achieve details and shading.

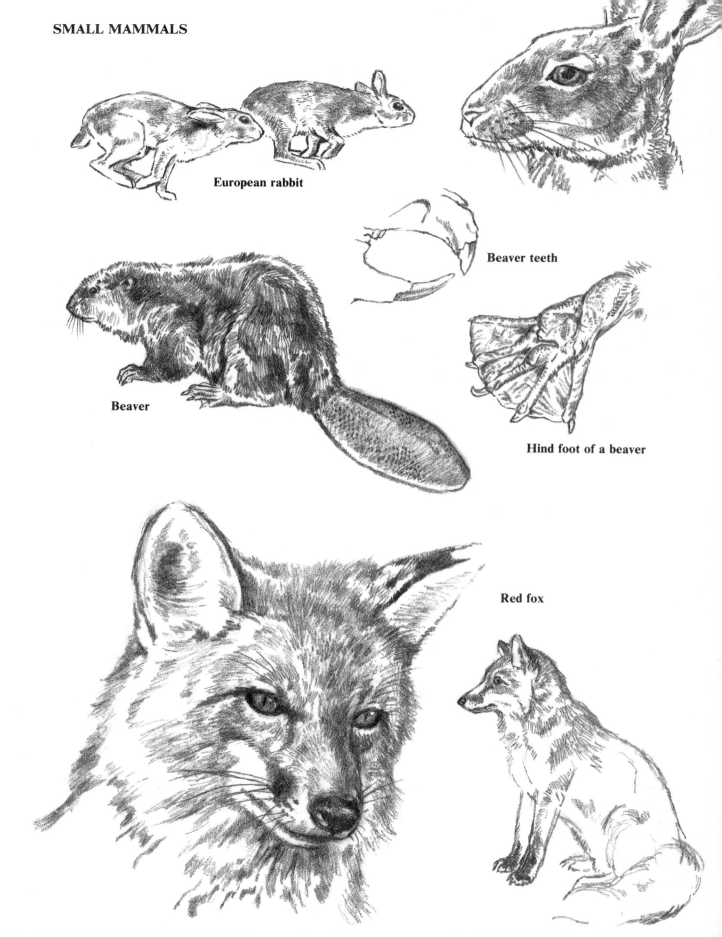

SMALL MAMMALS

European rabbit

Beaver teeth

Beaver

Hind foot of a beaver

Red fox

NOTES ON TECHNIQUES

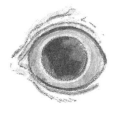 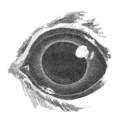

Fur texture begins with an overall wash of the basic color of the animal: red-brown, brownish gray, et cetera. The short hairs are gradually built up in more heavily opaque shades of the base color with small overlapping strokes. These will grow lighter or darker depending on where the shadow or light areas are on the animal. It is best at first to use variants of your base color. As experience grows, more colors can be added for effect.

When you have determined the exact shape of the eye and pupil of the species you are working with, wash in the base color of the iris, and shade it with tones of the same color. The dark brown-black of the pupil is painted in on top of the underlying iris color and carefully worked around the edges. At least two highlights are needed to give the eye a wet look: one where the pupil meets the iris, the other at the joint of the lid and the iris.

A beaver's fur is denser, longer, and slicker than a rabbit's fur. Clumping groups of brushstrokes together with darker shaded areas between them will produce the texture you want. The brushstrokes should always be "pulled" in the same direction, from the body outward. Consult your research material to establish in your mind the pattern in which the fur grows.

The tail of the beaver is scalelike in appearance. A close look at the overlapping scales will show that no two are exactly alike. Striations, or ridges, are produced by short, uneven brushstrokes following the direction of the ridges. An overall base color is washed in first and then overlaid with a darker tone for the details, shading slightly at the point of overlap. Accurate research material is an essential guide for this.

For the more lengthy fur of the fox, lift the brush slightly at the end of each stroke, to produce a long hairlike line that is slightly thicker at the base. Where clusters of hair or fur overlap, pick out the tips with a lighter, more opaque tone of the base color to accentuate the layers. Add highlights of almost pure white to create a sheen where necessary.

Nose color as well as eye color varies according to species. Begin with a light overall color as a base. Darken the inside area of the nostrils with a very deep shade of the same color, blending light tones to the outer surface of the nose. Nose leather has a minutely textured appearance, so when a highlight is added to give it a wet look, closely dot or stipple the brushstrokes to help make the texture convincing.

31

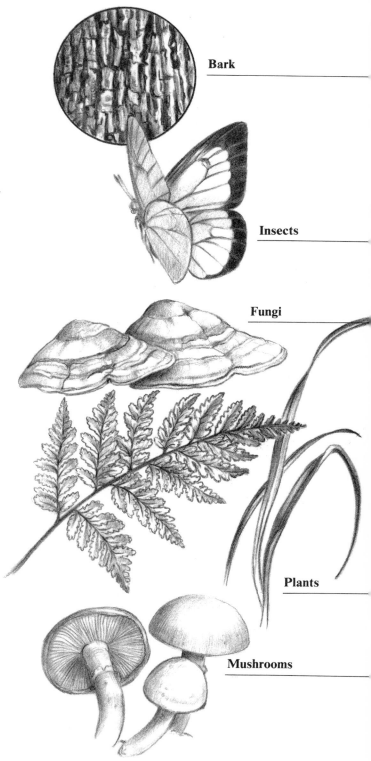

Bark

Insects

Fungi

Plants

Mushrooms

Humans can find living space nearly anywhere in the world, but animals are strongly bound to their ecological communities and many would find it impossible to contend with disruption of their natural life-style. They are perfectly adapted to environments that have provided every means for their survival, from the food they eat to their coat colors, which perhaps alter with the seasons. This interdependency is a circumstance that artists must not overlook. It becomes most evident when we are about to start a painting or drawing that contains a specific bird, and we begin to research the habitat most suited to it. What part of the world does the bird live in? What tree does it frequent, what are the leaves like, what kind of fruit or flowers does it bear? A vital and pleasant part of nature illustration is the research into the facts about subject matter. In order to convince your audience that it is seeing reality in your work, you cannot, in good conscience, veer from accuracy in the background material surrounding your subject.

The illustration for a children's book shown on the opposite page and in Plate 5 is a composite created to suggest what creatures might possibly live in a hollow tree. All of the plants, insects, animals, and birds come from the same ecological system. This oak could be a tree somewhere in a northeastern woodland. If it were a southern hardwood or western conifer, an entirely different wildlife community would inhabit it, and we would have to investigate its possible population before we put pencil to paper.

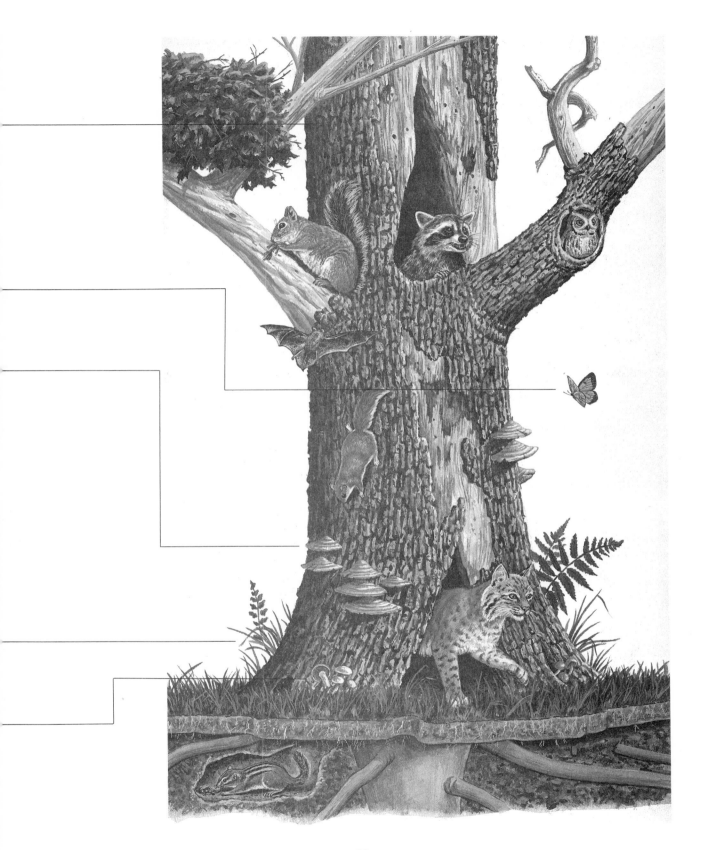

DEMONSTRATION: ANIMAL IN HABITAT

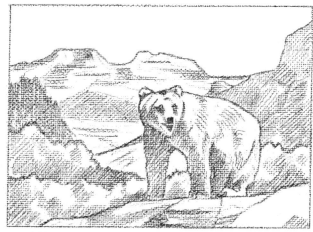

The research material for this oil painting (see Plate 1) was gathered over a period of years. The grizzly was photographed at the zoo, and the Kodachromes and some sketches were laid aside. The animal's pose had struck us as solid, dignified, characteristic of its species. Later we photographed a lot of scenery in the Rockies, and from our 35mm pictures we chose one that seemed appropriate as a background. The terrain area in our photos is its native habitat, so bear and mountains worked well together. A 24″ × 30″ canvas was stretched, and the sketch was laid out very roughly in charcoal. The painting had already been given much thought, and aside from minor details, placement of the bear in the landscape was elementary.

The rocks in the middle distance at right and the slope of the mountain range draw the eye to the bear in the foreground, bringing it into focus as the center of the composition. The trees at lower left lead your eye to the bear's front leg and gradually steps back to the far distant mountains. In roundabout fashion, everything points inevitably to the grizzly. The sketch proceeded to its final stages with a little more emphasis on minor details in the bear and a bit of shading in key landscape areas. Inconsequential minutiae in the photos were avoided in favor of the major shapes and the feel of the painting as a whole. As soon as a satisfactory drawing was on the canvas, several coats of fine spray of fixative were applied until the charcoal no longer showed signs of smearing.

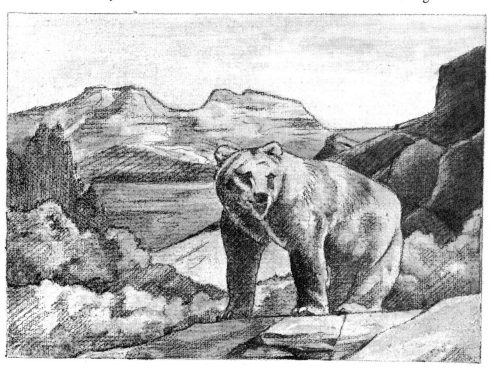

A thin mixture of turpentine and manganese blue was applied over the drawing, covering the entire canvas. When this was dry, the blocking-in began—a bold application of the oil color to delineate major color areas, done with medium-size brushes and with slightly less turpentine than was in the original wash. This allows the sketch to show through as a guide for later stages. The "blocking-in" here consisted of a mix of sap green and lemon yellow applied over the tree areas, tones of sienna and burnt umber on the darker areas of the bear, a very dark wash of burnt umber and black over the rocks in the right middle distance, and vague tints of cerulean blue and cobalt blue on the far distant range. The sky was left in the original wash. Thus roughed out, the canvas took on the semblance of what was to be the final color scheme.

34

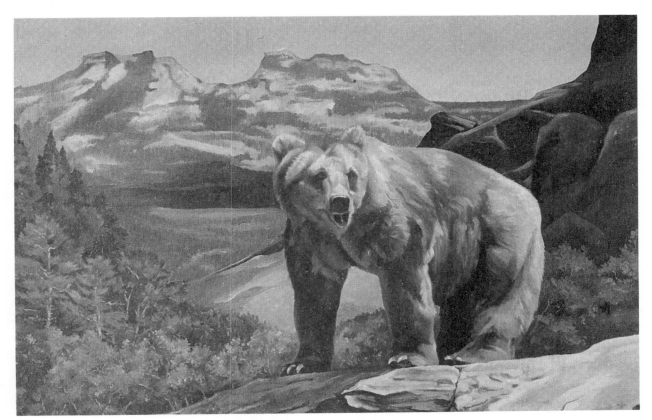

With the blocked-in painting finally dry, the next thing tackled was the sky, as much of the rest of the work depended on the color tone set by it. With a thickened mixture of cerulean blue, manganese blue, zinc white, and a touch of cobalt blue, the sky was painted in and kept flat, free of any clouds that might make the picture too busy. The mountains then received a bit more detail in shades of deeper cobalt, cerulean blue, and a hint of bluish mauve. Light areas in the mountain range were picked out in zinc white, with a little cerulean to kill down the white. Next, a strong burnt umber mixed with ivory black and raw umber in varying tones was applied to the rocks on the right, shaping them still further. Burnt sienna, vermilion, and cadmium yellow were mixed to bring out the middle tones of the bear's fur. Burnt umber was added to this mixture and worked into the shadow areas, with zinc white used for the light areas, going almost to a pure white in the extreme highlights on the head, shoulders, and hindquarters. The lightest points had to be the forehead and snout; these had to come forward a great deal. The eyes and nostrils were then darkened with burnt umber and jet black to give the head more form. Eventually the whitish claws—a mix of raw sienna and zinc white— were painted into the darkened paws. The ledge the bear is standing on also received a lighter treatment, mainly a mixture of Payne's gray and white with touches of raw sienna, to keep it simple yet light enough to step forward. Payne's gray and ivory black were added to the lighter colors for the shadow areas. Satisfied with the more detailed version of the bear and rocks, we began work on the right foreground trees. The foremost trees had a lot of lemon yellow mixed with the sap green and olive green. Indications of leaves were worked in for texture. For the step-back, the yellow was gradually removed from the other greens, and indigo blue and olive green, plus a little ivory black and burnt umber, were used for the trees in the far distance. The foot of the mountain range was done in tones of the same color, with a bit of zinc white and cerulean blue added to quiet it down. As the work on the trees progressed, their details underwent a change. General shapes were more important than a leafy rendering.

Although the Kodachromes had more or less set the pace and supplied a wealth of detail, they were now set aside, since the painting had become our own concept. Our memories of the live grizzly and the Rockies told us all we needed to know in order to guide our brush.

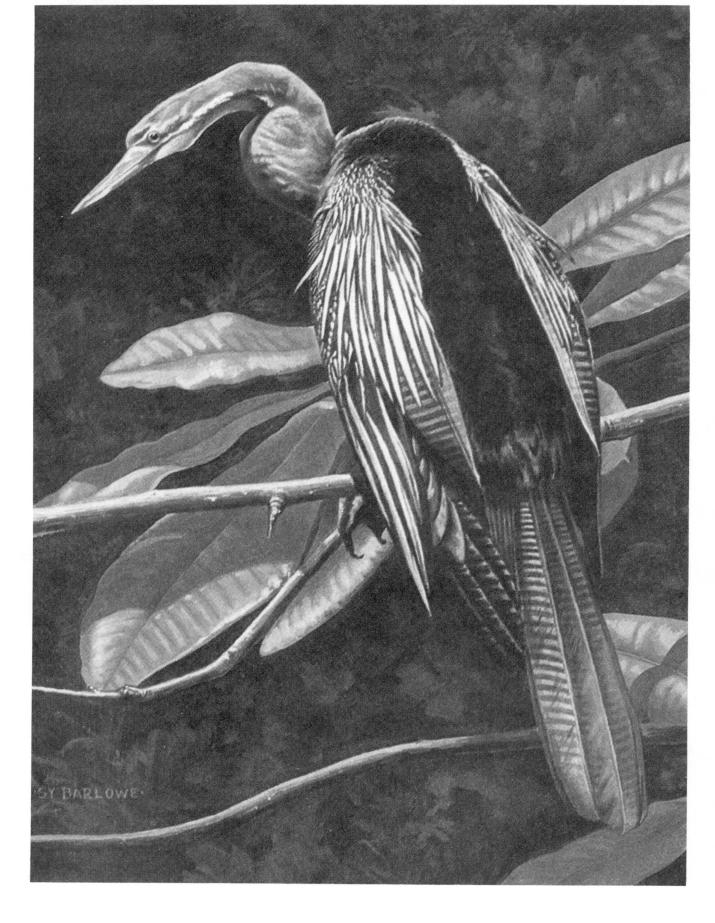

BIRDS

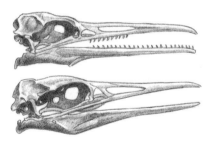

Skulls of the prehistoric bird
Hesperornis regalis (**top**) **and of
the common loon** (*Gavia immer*)

Birds in their infinite variety, their beautiful color, their graceful flight, and their musical presence give luster to what, without them, might have been very dull landscapes.

Anatomically, certain parallel bone structure and the scaled legs and feet are reminders of birds' prehistoric reptilian origins. Looking at them today it hardly seems possible that their feathers are nothing more than modified scales and that at birth the nestlings of the snowy owl and the eider duck still retain the egg tooth of the newborn reptile.

The Archaeopteryx and Archaeornis fossils of the late Jurassic period clearly show us the bird in its most primitive form: simple tail feathers, toothed beaks, and claws protrude from the upper wing structure of these early specimens. Knowing the ancestral background of the bird will help us to remember important physical details and relate them to the bird's present appearance.

Today we cannot in good conscience hunt birds in any way other than with a camera, a pair of binoculars, and an ever-observing eye. A pleasant walk through a nearby bird sanctuary with a 250mm or 500mm lens on a reasonably good camera should start you on your slide collection.

Opposite page: **Female anhinga
(*Anhinga anhinga*). See also
Plate 15.**

As you become more involved in the art of bird drawing or painting, your collection of photographs should grow to accommodate more ambitious work. Photographing or sketching at a zoo or museum is another way to gather material for an upcoming project. Many zoos have fine new concepts for housing birds, often displaying them in natural settings very like their native habitats. The added bonus of plants and flowers in the exhibits can help the artist to arrive at even more spectacular compositions.

A fortunate aspect of bird illustration is that the subject matter is available all year. During the winter months, feeding stations either outside a city window or in a suburban backyard garden provide abundant opportunity for the artist to continue working. Though the days are cold and the more exotic birds will have migrated, the many that still consistently return to the feeder and sit comfortably preening themselves on a nearby branch make willing models. Snow, pristine white with its translucent shadows, makes an excellent foil for the brilliance of a cardinal or blue jay. Chickadees and juncos, intrepid winter residents, have always been favorites of the bird illustrator. The black, gray, and white of these charming birds in winter seem almost perfect for pen-and-ink or various print techniques.

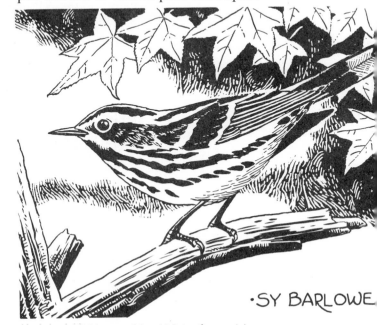

Black-and-white warbler (*Mniotilta varia*)

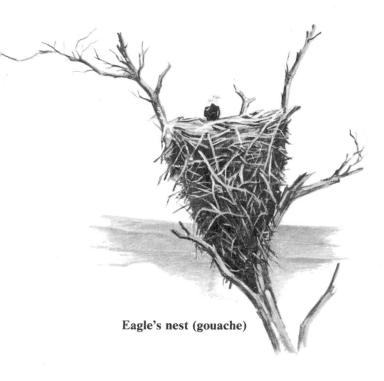

Eagle's nest (gouache)

All birds, the year round, make unparalleled subject matter for whatever technique you favor. They lend themselves well to pen-and-ink, etchings, block prints, fast pencil sketches, and, of course, the wonderful chance to say it all in color.

Because birds come in so many shapes and sizes, in the following chapter we have included details to help you sort out some of the major differences that separate them. Some birds, such as the numerous members of the warbler tribe, are remarkably similar in physical structure. The variations, as any astute bird watcher will tell you, lie in feather color and pattern. The careful artist, however, should be able to pick up minor points that escape the eye of the more casual observer in order to present a scientifically accurate rendering of the chosen warbler. Other families of birds run into similar problems, but perhaps not to so great an extent. For example, although most waterfowl have specialized characteristics that are common to all of them, body and head shapes fortunately vary sharply enough to define individual species and make things a little less confusing.

We have also included in this chapter a section on the background settings of branches or plants to accent your main theme. Many artists have based entire careers on illustrating birds, and we feel confident that there will always be a newcomer with a keen eye and persevering nature to perpetuate the tradition.

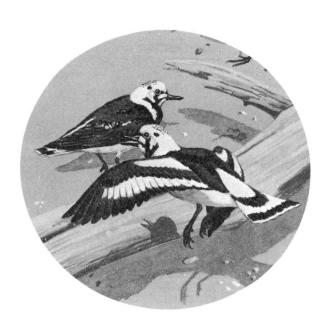

Ruddy turnstones (*Arenaria interpres morinella*), a detail of Plate 11

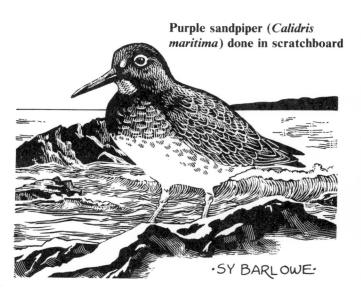

Purple sandpiper (*Calidris maritima*) done in scratchboard

·SY BARLOWE·

38

ANATOMY OF FEATHER GROUPINGS

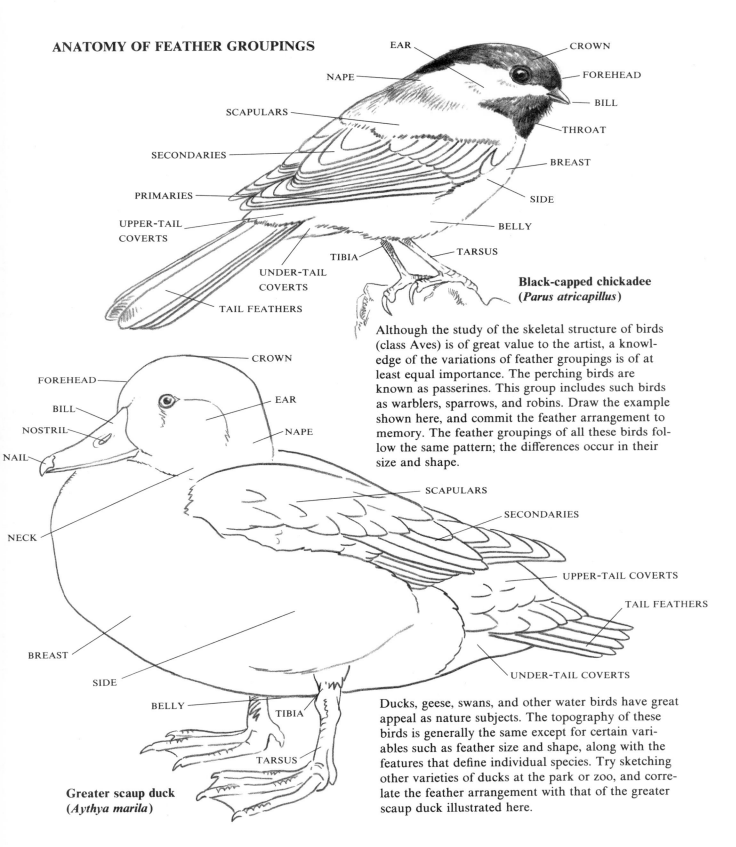

EAR

CROWN

NAPE

FOREHEAD

BILL

SCAPULARS

THROAT

SECONDARIES

BREAST

PRIMARIES

SIDE

UPPER-TAIL
COVERTS

BELLY

TIBIA

TARSUS

UNDER-TAIL
COVERTS

TAIL FEATHERS

**Black-capped chickadee
(*Parus atricapillus*)**

Although the study of the skeletal structure of birds
(class Aves) is of great value to the artist, a knowl-
edge of the variations of feather groupings is of at
least equal importance. The perching birds are
known as passerines. This group includes such birds
as warblers, sparrows, and robins. Draw the example
shown here, and commit the feather arrangement to
memory. The feather groupings of all these birds fol-
low the same pattern; the differences occur in their
size and shape.

CROWN

FOREHEAD

BILL

EAR

NOSTRIL

NAPE

NAIL

SCAPULARS

SECONDARIES

NECK

UPPER-TAIL COVERTS

TAIL FEATHERS

BREAST

UNDER-TAIL COVERTS

SIDE

BELLY

TIBIA

TARSUS

**Greater scaup duck
(*Aythya marila*)**

Ducks, geese, swans, and other water birds have great
appeal as nature subjects. The topography of these
birds is generally the same except for certain vari-
ables such as feather size and shape, along with the
features that define individual species. Try sketching
other varieties of ducks at the park or zoo, and corre-
late the feather arrangement with that of the greater
scaup duck illustrated here.

FEATHERS

When drawing or painting the patterns on feathers, take care to integrate the pattern color along the "barb" lines. Indiscriminate dotting or spotting on an already finished drawing will result in a haphazard pattern that may not truly depict the species or impart a lifelike appearance.

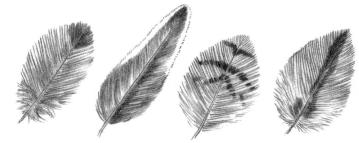

Spotted **Margined** **Barred** **Streaked**

Iridescence is one of the most difficult impressions to create. It is influenced, to a great extent, by the bird's body color. One simple means of achieving a satisfactory effect is to paint pale bands of the spectrum, from yellow through blue-violet, rainbow fashion, into the already highlighted areas of the feathers.

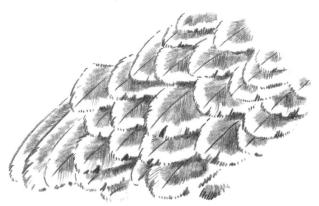

Contour feathers

If an overlapping of patterned feathers occurs, as it does on many birds, accurately sketch the number and placement of the feathers before you begin the finished art, indicating the pattern lightly to avoid later confusion. The edges of the feathers of a living bird are never perfectly even. To avoid a wooden look, spread or notch the edges at random along their lower edges. In painting the color, follow the barbs downward from the shafts. Work the pattern directly as you go along, or overpaint it when the feathers are complete, as shown above. Use delicate shading in a darker tone of your basic color at the point of overlap for the appropriate shingled effect.

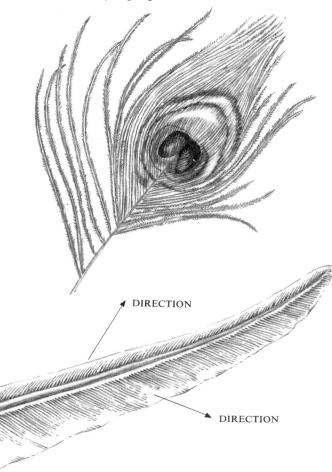

DIRECTION

DIRECTION

SHAFT

BARB

Primary feather

Except for down feathers, all outer feathers are built around the quill, or shaft. The barbs are attached to the shaft, and your drawings and paintings should indicate this. Strokes should extend outward from the shaft in the direction shown here.

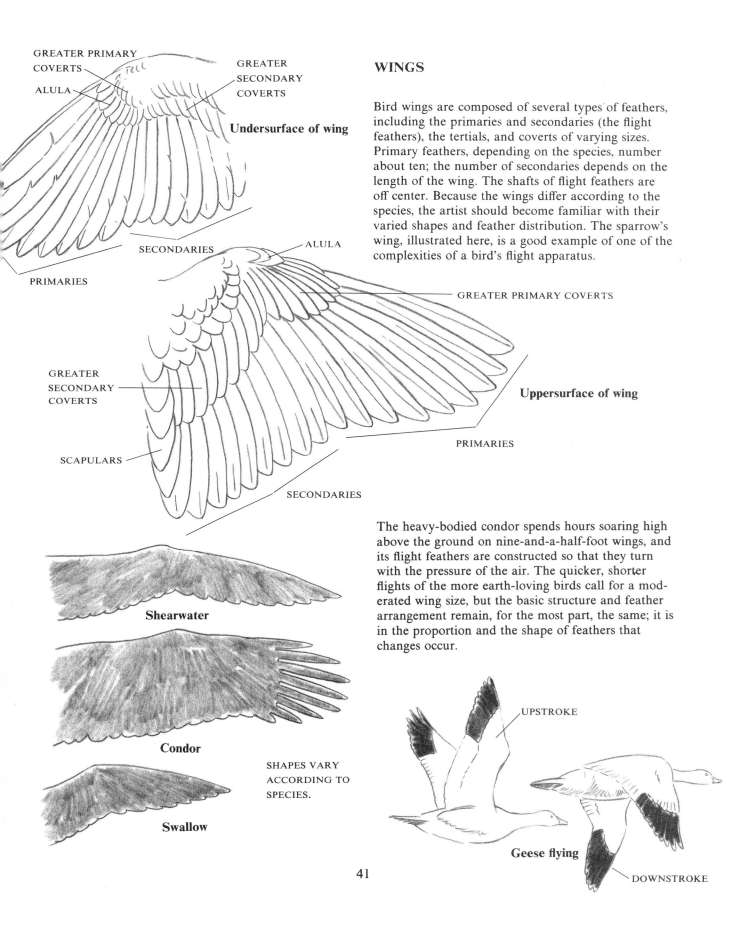

GREATER PRIMARY COVERTS

ALULA

GREATER SECONDARY COVERTS

Undersurface of wing

PRIMARIES

SECONDARIES

ALULA

GREATER PRIMARY COVERTS

GREATER SECONDARY COVERTS

Uppersurface of wing

PRIMARIES

SCAPULARS

SECONDARIES

Shearwater

Condor

Swallow

SHAPES VARY ACCORDING TO SPECIES.

WINGS

Bird wings are composed of several types of feathers, including the primaries and secondaries (the flight feathers), the tertials, and coverts of varying sizes. Primary feathers, depending on the species, number about ten; the number of secondaries depends on the length of the wing. The shafts of flight feathers are off center. Because the wings differ according to the species, the artist should become familiar with their varied shapes and feather distribution. The sparrow's wing, illustrated here, is a good example of one of the complexities of a bird's flight apparatus.

The heavy-bodied condor spends hours soaring high above the ground on nine-and-a-half-foot wings, and its flight feathers are constructed so that they turn with the pressure of the air. The quicker, shorter flights of the more earth-loving birds call for a moderated wing size, but the basic structure and feather arrangement remain, for the most part, the same; it is in the proportion and the shape of feathers that changes occur.

UPSTROKE

Geese flying

DOWNSTROKE

41

EGGS, NESTS, AND YOUNG

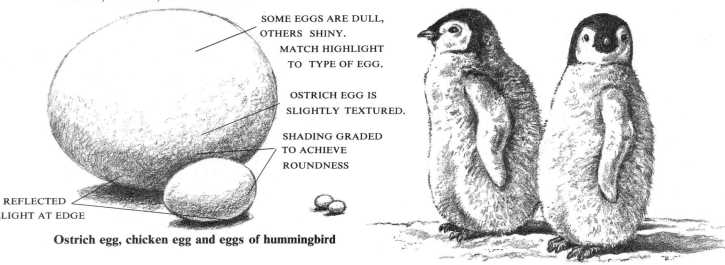

SOME EGGS ARE DULL,
OTHERS SHINY.
MATCH HIGHLIGHT
TO TYPE OF EGG.

OSTRICH EGG IS
SLIGHTLY TEXTURED.

SHADING GRADED
TO ACHIEVE
ROUNDNESS

REFLECTED
LIGHT AT EDGE

Ostrich egg, chicken egg and eggs of hummingbird

Young penguins (pencil)

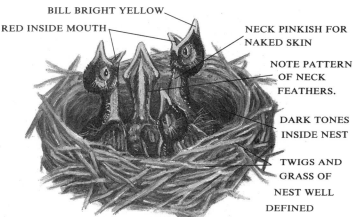

BILL BRIGHT YELLOW
RED INSIDE MOUTH
NECK PINKISH FOR
NAKED SKIN

NOTE PATTERN
OF NECK
FEATHERS.

DARK TONES
INSIDE NEST

TWIGS AND
GRASS OF
NEST WELL
DEFINED

Nest with robin nestlings (gouache)

Nests vary as much as the birds that build them, and the places they choose as sites for them are just as diverse. Although some nests are a jumbled conglomeration of either twigs or grasses, or a combination of both, the drawing should reflect the particular character of both the nest and the nestlings of the species being illustrated.

The eggs of birds have an exquisite beauty. Their colors vary from species to species and there are even subtle differences in subspecies. Eggs are speckled, striped, blotched, or solid-colored, all in the interest of camouflage. Never collect birds' eggs; it is not only unlawful but unjustified. You have alternatives. If you are fortunate enough to come across a nest with eggs, use your camera or sketch pad and carefully jot down any data that might prove useful for future reference. Museum exhibits and photos obtained from books on ornithology are other sources of information for your work.

An excellent practice subject is an ordinary chicken egg. Try for the solidly rounded appearance indicated by the illustration at top.

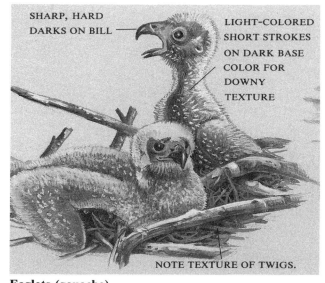

SHARP, HARD
DARKS ON BILL

LIGHT-COLORED
SHORT STROKES
ON DARK BASE
COLOR FOR
DOWNY
TEXTURE

NOTE TEXTURE OF TWIGS.

Eaglets (gouache)

BEAKS, EYES, AND FEET

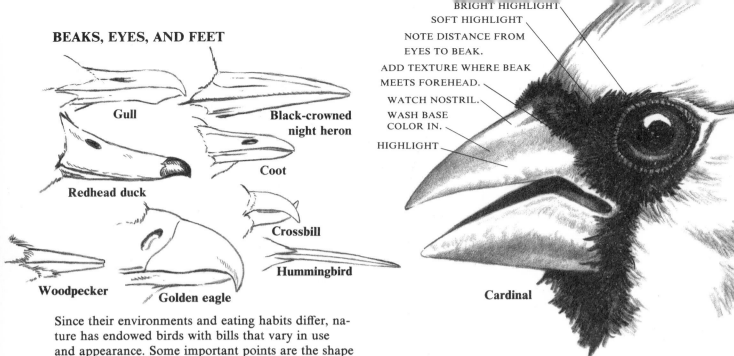

Gull

Black-crowned night heron

Coot

Redhead duck

Crossbill

Hummingbird

Woodpecker

Golden eagle

BRIGHT HIGHLIGHT
SOFT HIGHLIGHT
NOTE DISTANCE FROM
EYES TO BEAK.
ADD TEXTURE WHERE BEAK
MEETS FOREHEAD.
WATCH NOSTRIL.
WASH BASE
COLOR IN.
HIGHLIGHT

Cardinal

Since their environments and eating habits differ, nature has endowed birds with bills that vary in use and appearance. Some important points are the shape of the upper and lower mandible, its proportion in relation to the head, the location of the nostrils, and the placement of the eyes with regard to the position of the bill. Properly highlighting the bill will accent the horny texture and create a needed contrast with the head feathers. The eyes, which can be very expressive, often have a beautifully colored iris, and care must be taken to ensure that the color applied is correct for the particular species. The area around the

eye may be bare of feathers (on pelicans, for example) or there may be an eye ring composed of feathers of a different color from the ones surrounding them. The shape of the eyebrows and eyelids may form an integral part of the bird's expression, as, for instance, in the fierce, hooded look of the hawk or eagle, or the beautifully comical look of an ostrich's eyes, complete with lashes.

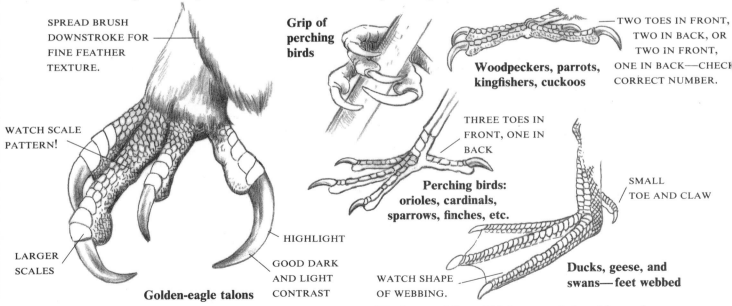

SPREAD BRUSH
DOWNSTROKE FOR
FINE FEATHER
TEXTURE.

WATCH SCALE
PATTERN!

LARGER
SCALES

Golden-eagle talons

HIGHLIGHT

GOOD DARK
AND LIGHT
CONTRAST

Grip of perching birds

Woodpeckers, parrots, kingfishers, cuckoos

TWO TOES IN FRONT, TWO IN BACK, OR TWO IN FRONT, ONE IN BACK—CHECK CORRECT NUMBER.

THREE TOES IN FRONT, ONE IN BACK

Perching birds: orioles, cardinals, sparrows, finches, etc.

SMALL TOE AND CLAW

WATCH SHAPE OF WEBBING.

Ducks, geese, and swans—feet webbed

The legs and feet of birds are scaled and horny in appearance, with two, three, or four toes, depending on the family. Toe color often identifies the species.

43

BIRDS AND PLANTS

The cuckoo below is in the midst of song, throat feathers fluffed out, beak opened wide, and wings held low in a characteristic pose. He is perched on the flowering branch of an apple tree. It is spring, and the blossoms are opening, but the leaflets are just beginning to appear. Two important things we had to remember when doing this illustration were that this male bird's plumage had to correspond to the spring setting and that the leaves had to be the correct size in relation to the blossoms.

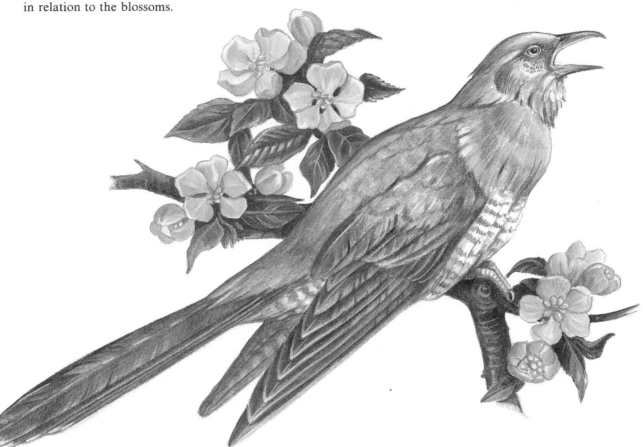

Never underestimate the value of the background material you have chosen to incorporate into your bird painting or drawing. To pretend that any flower, leaf, or branch will suffice, or, worst of all, that something that just "looks like" a leaf or flower is acceptable, is a tactical mistake. Birds and the world they live in are highly integrated. Each group has specific feeding and nesting habits, and the environment always meets these needs.

One way to begin to draw or paint birds in a full habitat is to choose a bird from your own area, so that you will have excellent living examples close at hand. You will be fully aware of the habits and characteristics of birds that live nearby and will be able to either photograph or gather suitable wild plants to use as backgrounds for your bird. A sketchbook filled with sketches of flowers, twigs, branches, rocks, and grasses—anything you might possibly want to adapt for one of your paintings—is invaluable. Start one today!

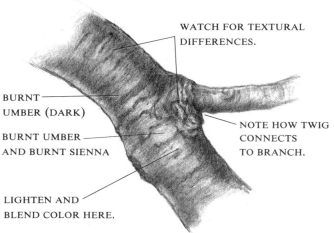

WATCH FOR TEXTURAL DIFFERENCES.

BURNT UMBER (DARK)

BURNT UMBER AND BURNT SIENNA

NOTE HOW TWIG CONNECTS TO BRANCH.

LIGHTEN AND BLEND COLOR HERE.

Branch of apple tree

Apple leaves and blossoms

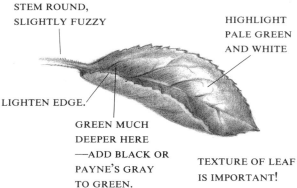

STEM ROUND, SLIGHTLY FUZZY

HIGHLIGHT PALE GREEN AND WHITE

LIGHTEN EDGE.

GREEN MUCH DEEPER HERE —ADD BLACK OR PAYNE'S GRAY TO GREEN.

TEXTURE OF LEAF IS IMPORTANT!

Developing an accurate background is the first of a series of steps leading to a handsome bird painting. Remember, though, that the viewer's eye must always return to the center of interest. The colors of the plants, flowers, or other details should never overshadow the brilliance of the bird. An ability to play down the color comes with a certain amount of experience. For the beginner, however, we suggest that pale tones rather than dark ones be used in the flowers and leaves. If a sky appears behind the subjects, do it first, as it is very difficult to paint around small images.

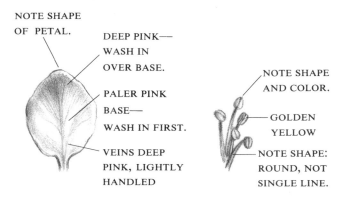

NOTE SHAPE OF PETAL.

DEEP PINK— WASH IN OVER BASE.

PALER PINK BASE— WASH IN FIRST.

VEINS DEEP PINK, LIGHTLY HANDLED

NOTE SHAPE AND COLOR.

GOLDEN YELLOW

NOTE SHAPE: ROUND, NOT SINGLE LINE.

DEMONSTRATION: SCRATCHBOARD
DRAWING OF AN OWL

The illustration on the opposite page was prepared on scratchboard. This delightful medium has all sorts of possibilities for the artist interested in black-and-white, and it is inexpensive to reproduce. In its final stage, it most resembles a line engraving or woodcut, and the more experienced one becomes, the finer and more even-textured the work will be.

Scratchboard is a thin board that has a surface coating of chalk polished to a very smooth finish. The white surface takes India ink very easily. Once the ink is dry, it can be cut or scratched with a small, sharp blade to produce white lines in the black ground. Our experience shows that the store-bought scratchboard nib in a penholder, a tiny frisket knife, or just about any tool that has a sharp point can be used to scrape away the ink. For the more experimental artist, there are multiple-pointed tools that will scratch three or more parallel lines at a time, and are thus really valuable aids for texturing.

Scratchboard can be purchased in any well-stocked art-supply store. Because the thin sheets have a tendency to crack, it is wise to mount them with rubber cement on chipboard or on any sturdy inexpensive illustration board. Black scratchboard is also available, its surface precoated with ink. This is primarily a convenience for making what are known as "reverse images"—white drawings on a black background, rather than the black-on-white illustrations shown here.

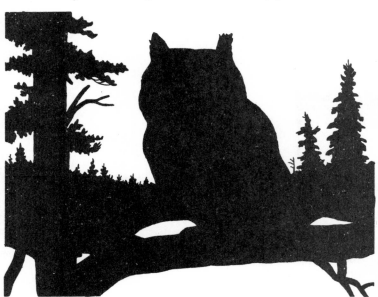

After the inked-in silhouette had been left to dry for three or four hours, the sketch was flipped back down and white Saral tracing paper placed between sketch and silhouette. Details of the owl and the background were then traced onto the black silhouette, making a white line drawing on the black ground. The black was then gradually cut and scraped away along the lines of the drawing, following our photographic copy and the original sketch.

At left is a silhouette made from a carefully worked out sketch of the owl and its background. Only the outlines were traced onto the mounted scratchboard, using black Saral tracing paper. The sketch, held by masking tape along its top edge, was flipped up during the inking process and kept taped in place until the second tracing had been done, to ensure correct alignment. Owl and background were then inked in solidly with Higgins Black Magic ink. The broad areas that were to remain white were left free of ink.

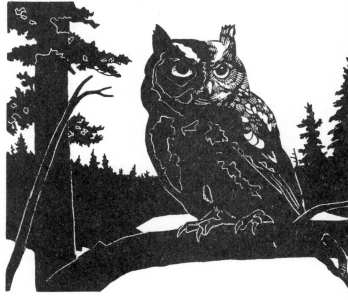

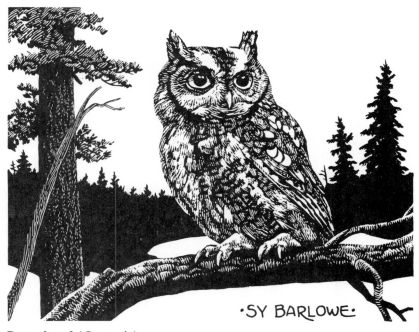

Screech owl (*Otus asio*)

For the artist whose imagination has been fired by this technique, there is a wealth of inspiration in old books with line engravings. These were often done by masters of the art whose ideas for textures and black-and-white content can be studied and applied to this more modern medium.

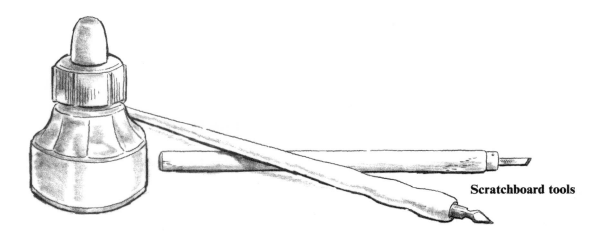

Scratchboard tools

FISHES AND OTHER MARINE LIFE

Of all the natural-science subjects available to the artist, the sea and its uncounted living inhabitants have been the least exploited. We have walked along the inland and coastal beaches of Long Island, as well as along some of the more remote strands of Florida and Oregon, and have never failed to find specimens of shells and other fascinating bits and pieces of flotsam waiting to be gathered. Though such marvelous things make fine subjects to work with and are easy to come by, it is of course the fish that have an overriding fascination. We cannot help but wonder about the complexities of the lives of these moving, living creatures. The fish is to the sea what the mammal is to the land, and its habitat, teeming with unbelievably beautiful plants and animals, are the fields, meadows, and jungles of its aquatic environment. There, you, the artist, have a wealth of subject matter that merits special attention. The more you become acquainted with the underwater world, the more astonishing it appears. What we think of as flowers suddenly erupt into action and remind us that they are animals. Coral reefs that form havens for tropical fish are rocks at one moment and a mass of living organisms the next; the floating, innocuous-looking jellyfish is in reality well armed with stinging tentacles that belie its apparent fragility.

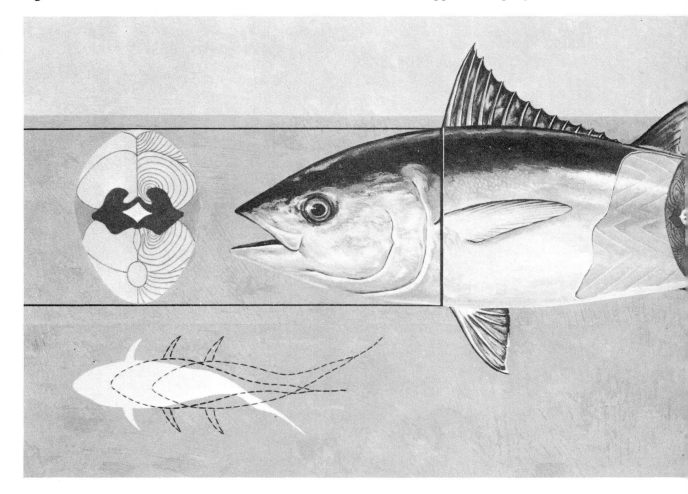

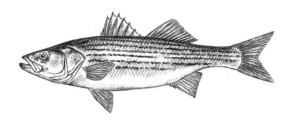

Striped bass (*Morone saxatilis*)

It is true that if you do not count scuba diving among your hobbies, the doors to the aquatic world will remain closed to you unless you take special measures. Fortunately some aquariums have very fine exhibits, and visiting one several times with sketch pad or camera is of great value. Carefully observing fish of various kinds, moving and at rest, can yield volumes of information. Their habitats and the manner in which they make use of them should inspire you with new ideas and suggest exciting compositions.

Aside from the aesthetic, there is the technical aspect. Fish are not merely shape and form. They have as many physical differences as there

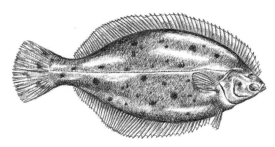

**Winter flounder
(*Pseudopleuronectes americanus*)**

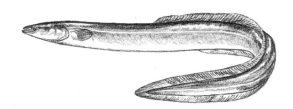

American eel (*Anguilla rostrata*)

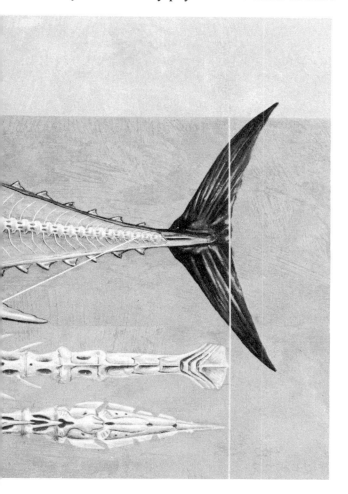

**Anatomy and cross section of a
bluefin tuna (*Thunnus thynnus*).
See also Plate 6.**

49

Eel

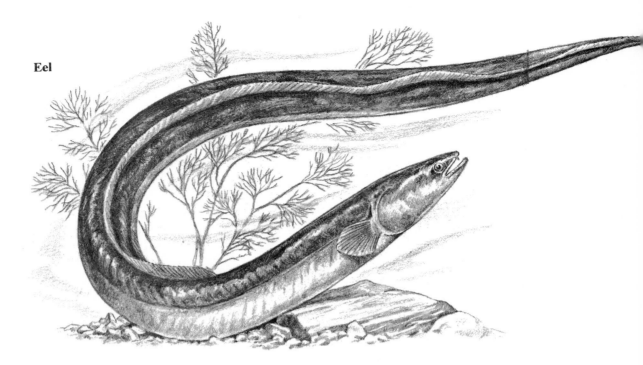

are species, and the artist's prime task is to give an accurate account of these variations. There are scale, eye, fin, and tail differences; color and pattern must also be dealt with. The part of the lake, river, stream, pond, or ocean the fish lives in will often give clues to its anatomical structure. All of this is a study unto itself. Drawing fish requires diligence, but the effort is well rewarded by the exquisite design and lifelike appearance of the finished product.

Whether the fish lives in the open ocean or among coral reefs, there is additional study needed to render accurately the graceful drift of water or the plants and animals that thrive abundantly on the sea bottom.

Along with the material that can be collected through beachcombing, you may purchase specimens from a biological supply house. Though the colors of preserved specimens may have long since faded, consulting photographs and books can help to overcome this deficiency. To understand form, we have gone through the process of buying a fish at the market, boiling it, and removing the flesh to get as complete a skeleton as possible for anatomical work.

Grinnellia (seaweed)

ANATOMY OF FISHES

Like all other animals, different species of fish (class Pisces for the bony fishes we are all most familiar with) vary in external appearance depending on their environmental needs. However, the artist should have a good working knowledge of a fish's anatomy.

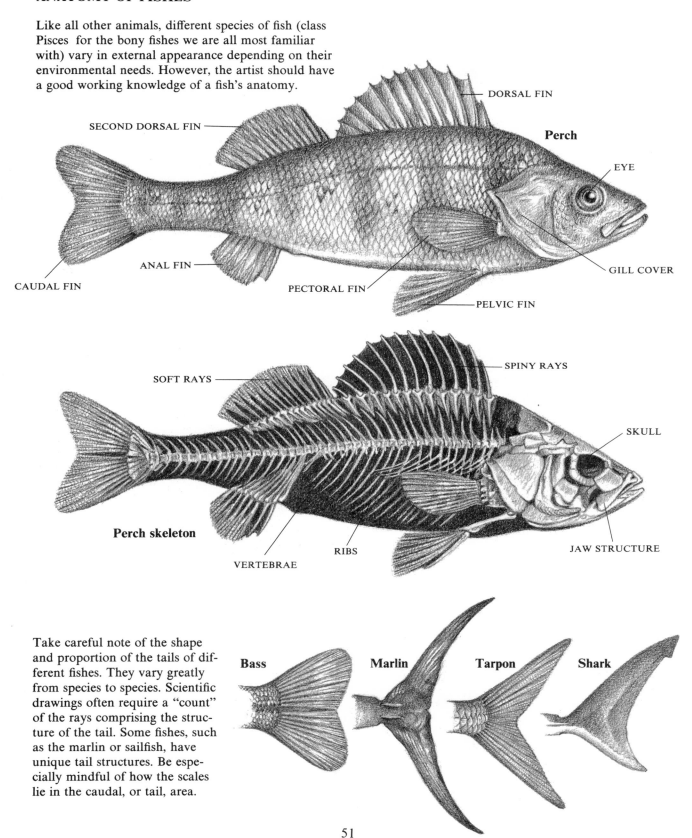

SECOND DORSAL FIN

DORSAL FIN

Perch

EYE

GILL COVER

CAUDAL FIN

ANAL FIN

PECTORAL FIN

PELVIC FIN

SOFT RAYS

SPINY RAYS

SKULL

Perch skeleton

VERTEBRAE

RIBS

JAW STRUCTURE

Take careful note of the shape and proportion of the tails of different fishes. They vary greatly from species to species. Scientific drawings often require a "count" of the rays comprising the structure of the tail. Some fishes, such as the marlin or sailfish, have unique tail structures. Be especially mindful of how the scales lie in the caudal, or tail, area.

Bass **Marlin** **Tarpon** **Shark**

51

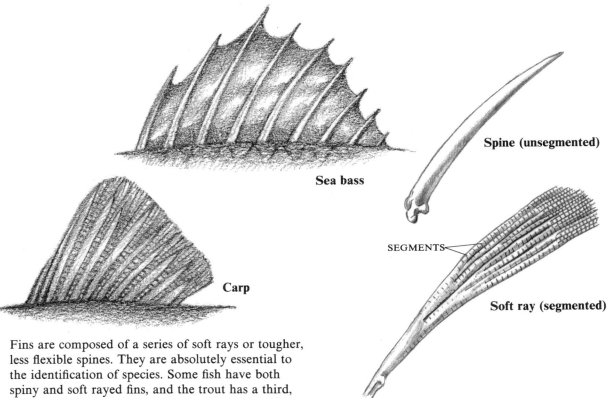

Sea bass

Carp

Spine (unsegmented)

SEGMENTS

Soft ray (segmented)

Fins are composed of a series of soft rays or tougher, less flexible spines. They are absolutely essential to the identification of species. Some fish have both spiny and soft rayed fins, and the trout has a third, less common variety known as an adipose fin. This is behind the dorsal fin and is made of fatty tissue lacking spines or rays. The artist should take full advantage of the flexibility of fins, as they are a marvelous device for implying underwater movement.

In illustrative painting and drawing, a precise ray count is not so important as accuracy in shape, size, and placement, but scientific illustration requires a perfect count because the ichthyologist is dealing with classification.

Models are easily accessible in the local fish market. Examination of fins and tails at close range can be very enlightening.

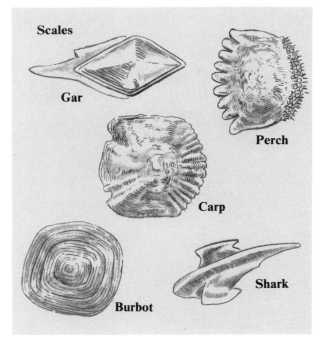

Scales

Gar

Perch

Carp

Burbot

Shark

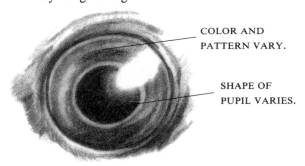

COLOR AND PATTERN VARY.

SHAPE OF PUPIL VARIES.

Although the eye of a fish may appear expressionless, it actually provides the artist with a means to animate a drawing with a well-placed highlight. Take care to make the color, shape, and placement in the head as accurate as possible. Color variation may identify male and female as well as species.

Scales come in as many shapes as there are species of fish. If an exceptionally accurate drawing is required, it is vital to know something of the shape of your specimen's scales. It is not so important in a more generalized painting, providing the relative size of the scales is taken into account.

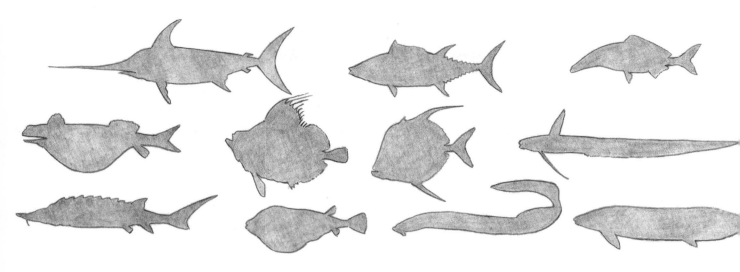

The variety of the shapes of fishes found in the watery world of sea, river, lake, and pond is so incredible that an artist cannot help but be inspired. It offers an almost limitless horizon of designs for jewelry, sculpture, paintings, and illustration.

There is hardly a subject we have spent more time in studying that the young of fish. Long ago we learned that a young fish is not always a smaller version of the adult. Although many young fishes do resemble the mature adult, with slight anatomical differences, some, such as the sunfish and eel, look nothing at all like the parents. Another example of this biological treachery is the flatfishes, such as the flounder and fluke. As babies they look much like other unidentifiable small fish, but maturity gradually brings their eyes around to one side of their head and their bodies become narrow and flat, enabling them to lie close to the sandy sea bottom, viewing the world above without revealing their presence.

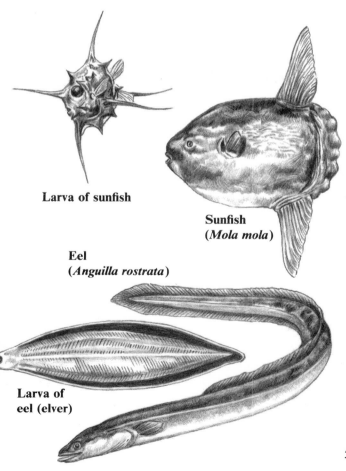

Larva of sunfish

**Sunfish
(*Mola mola*)**

**Eel
(*Anguilla rostrata*)**

**Larva of
eel (elver)**

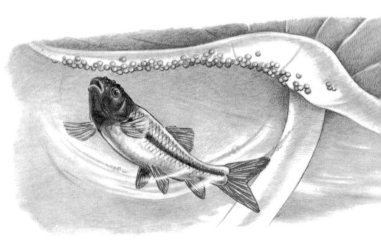

Fathead minnow (*Pimephales promelas*) tending its eggs

HOW FISH MOVE

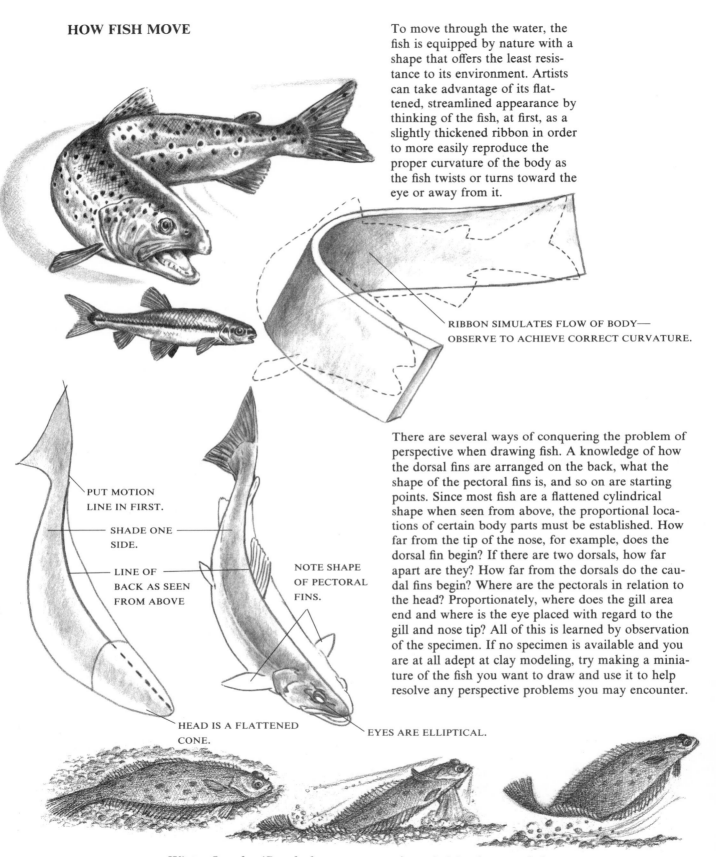

To move through the water, the fish is equipped by nature with a shape that offers the least resistance to its environment. Artists can take advantage of its flattened, streamlined appearance by thinking of the fish, at first, as a slightly thickened ribbon in order to more easily reproduce the proper curvature of the body as the fish twists or turns toward the eye or away from it.

RIBBON SIMULATES FLOW OF BODY—
OBSERVE TO ACHIEVE CORRECT CURVATURE.

PUT MOTION
LINE IN FIRST.

SHADE ONE
SIDE.

LINE OF
BACK AS SEEN
FROM ABOVE

NOTE SHAPE
OF PECTORAL
FINS.

There are several ways of conquering the problem of perspective when drawing fish. A knowledge of how the dorsal fins are arranged on the back, what the shape of the pectoral fins is, and so on are starting points. Since most fish are a flattened cylindrical shape when seen from above, the proportional locations of certain body parts must be established. How far from the tip of the nose, for example, does the dorsal fin begin? If there are two dorsals, how far apart are they? How far from the dorsals do the caudal fins begin? Where are the pectorals in relation to the head? Proportionately, where does the gill area end and where is the eye placed with regard to the gill and nose tip? All of this is learned by observation of the specimen. If no specimen is available and you are at all adept at clay modeling, try making a miniature of the fish you want to draw and use it to help resolve any perspective problems you may encounter.

HEAD IS A FLATTENED
CONE.

EYES ARE ELLIPTICAL.

Winter flounder (*Pseudopleuronectes americanus*) rising from sandy bottom

NOTES ON TECHNIQUE

The discipline of counting scales and rays is a practical way of gaining further understanding of fish anatomy. An artist dedicated to illustrating fish must have a working knowledge of how the scales lie.

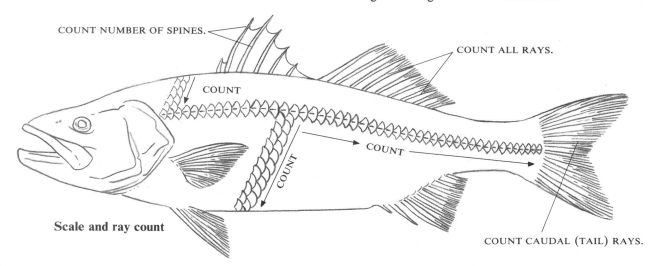

COUNT NUMBER OF SPINES.

COUNT ALL RAYS.

COUNT

COUNT

COUNT

COUNT

Scale and ray count

COUNT CAUDAL (TAIL) RAYS.

Scales are lightly drawn as a carefully counted crosshatch, and then rounded or shaped so as to overlap. Reference to a specimen or good photograph should indicate the angle of the crosshatch and where the scales widen and narrow on the body.

NOTE PATTERN
AND SCALES AROUND
EYES.

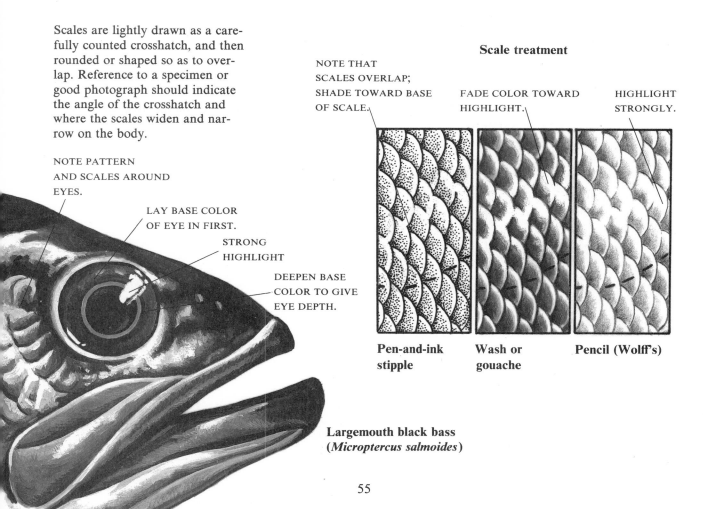

LAY BASE COLOR
OF EYE IN FIRST.

STRONG
HIGHLIGHT

DEEPEN BASE
COLOR TO GIVE
EYE DEPTH.

Scale treatment

NOTE THAT
SCALES OVERLAP;
SHADE TOWARD BASE
OF SCALE.

FADE COLOR TOWARD
HIGHLIGHT.

HIGHLIGHT
STRONGLY.

Pen-and-ink stipple

Wash or gouache

Pencil (Wolff's)

Largemouth black bass
(***Microptercus salmoides***)

55

FISH AND THEIR HABITAT

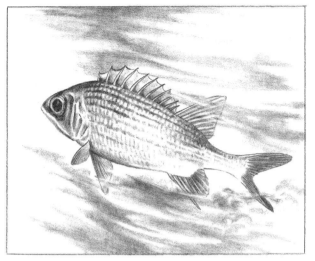

WATER

If you look at a photograph of a fish underwater, you will notice that evidence of movement is indiscernible. The fish, in adaptation to its environment, has a coating of slime that allows it to maneuver without any perceptible movement of the water around it. But the artist must on occasion include some illustrative means of suggesting such movement. Along with showing details such as flattened fins, a curved body and tail, and an open mouth, the addition of bubbles or a water pattern following the forward progress of the fish should be worked into the composition. Plants, as background material, should be drawn in such a way as to further the notion that all is not motionless around the moving fish.

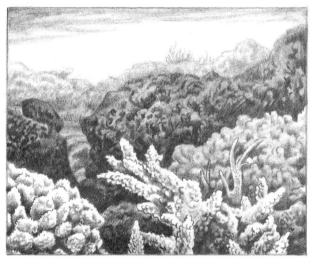

CORALS

Artists are fortunate to be able to use fantastic corals as background material for tropical fish. Corals are so varied in shape and color that it seems there is one for almost any composition you have in mind. To achieve the stepback often desired in panoramic underwater scenes, the coral in the extreme foreground here is made more detailed and its dark and light contrast sharper. As the drawing recedes, the shapes gradually take on a more shadowy appearance. Detail should be increasingly subdued until the coral fades into tones close to the hue of the water. Start by applying a pale overall tint of the color chosen for the water. This will help to hold the painting together and create a much wanted illusion of the underwater world, where no strong light penetrates.

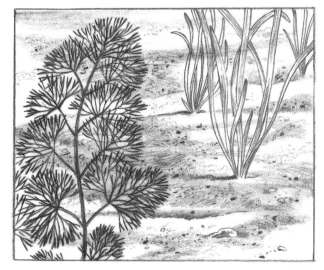

PLANTS

Many plants, including some seaweeds, are rooted in sandy bottoms much as land plants are rooted in soil. For them to look natural in their underwater setting, rendering should be graceful and detail held to a minimum. As no body of water is ever completely still, the flowing and drifting of seaweeds or rooted plants should be accented. The habitat of underwater plants varies considerably, and a certain amount of study is required to avoid placing the plants in the wrong environment.

Water

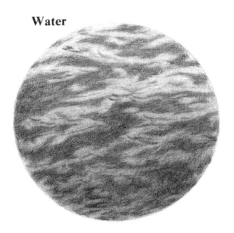

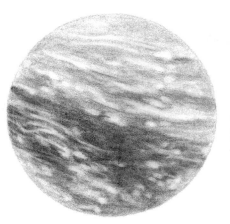

SURFACE AS SEEN FROM BELOW—RIPPLES REFLECTING SUN OR LIGHT FORM INTRICATE PATTERNS.

BLEND TONES OF OLIVE OR YELLOW-GREEN TO ACHIEVE EFFECT OF MOVEMENT—AREA SHAPES SHOULD NOT BE REPETITIOUS BUT SHOULD FOLLOW SET DIRECTION.

WATER CAN BE JUST ONE COLOR BLENDED FROM LIGHT ON TOP TO MUCH DEEPER SHADES AS IT GOES FARTHER DOWN, WHERE THERE ISN'T MUCH LIGHT.

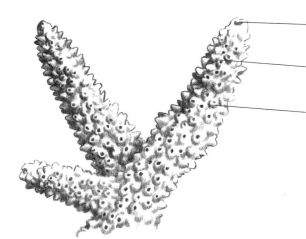

USE DARK COLOR TO INDICATE HOLLOW, TUBELIKE TIP.

USE DARKEST COLOR TO INDICATE HOLE WHERE POLYP LIVED OR STILL LIVES.

EACH KNOB MUST BE SHADED TO INDICATE ITS OUTWARD GROWTH; A LITTLE GRAY OR BLACK MIXED WITH THE BASIC COLOR SHOULD BE USED FOR SHADING BENEATH KNOB.

THE COLOR FOR CORAL DEPENDS ON SPECIES, DEPTH IN WATER, AND SURROUNDING SCENERY. PALE GRAY-GREEN IS A GOOD STARTING COLOR FOR WHITE CORAL SUCH AS THIS SPECIMEN.

Staghorn coral (genus *Acropora*)

SAND IN THE BACKGROUND IS DIFFUSED; THE FARTHER BACK IT IS, THE MORE IT TENDS TO BLEND INTO WATER TONES.

A STIPPLE EFFECT, DONE WITH BRUSH, PENCIL, OR PEN, PRODUCES THE DESIRED TEXTURE. CAREFUL ATTENTION TO GROWTH PATTERN OF PLANT IS SUGGESTED.

AS POINT OF VIEW CHANGES, SAND IN FOREGROUND BECOMES MORE AND MORE SHARPLY DEFINED, MOVING FROM SMALL GRAINS TO MINIATURE PEBBLES. A BIT OF BROKEN SHELL HELPS TO ENHANCE THE EFFECT.

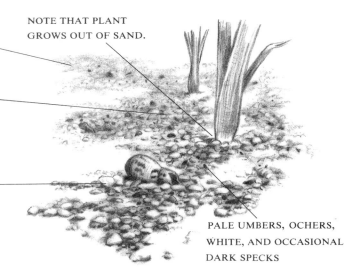

NOTE THAT PLANT GROWS OUT OF SAND.

PALE UMBERS, OCHERS, WHITE, AND OCCASIONAL DARK SPECKS

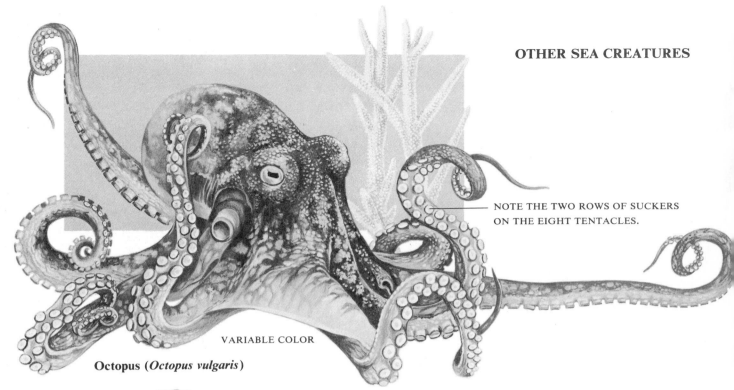

NOTE THE TWO ROWS OF SUCKERS
ON THE EIGHT TENTACLES.

VARIABLE COLOR

Octopus (*Octopus vulgaris*)

SUCKER DISC

Maligned and misunderstood, the octopus is an
intelligent, graceful creature. Its ability to change
color to fit circumstances is uncanny. It has highly
flexible and sensitive tentacles, bright eyes, and a
great deal of personality, which the artist can use to
full advantage. Octopuses as a species are only one of
countless undersea creatures, aside from fish, that
may be used to enhance paintings and drawings. If it
is impossible for you to get out there and snorkel in
the wonderful world beneath the ocean's surface,
there are many excellent photographic books that can
be used to stimulate your imagination.

Many years ago, when illustra-
tions for a book called *Seashores*
was a project we had under way,
we spent many worthwhile hours
learning about our craft, not just
at the drawing board but also at
the source. The beaches of Long
Island were one of several happy
hunting grounds for specimens.
Detritus drifts were carefully
picked over, and we were over-
joyed when a specimen we had
long sought was finally discov-
ered. The book came to life as sea
forms known to us only by scien-
tific name and text description fell
our way, and we were able to add
them to our burgeoning collec-
tion.

OTHER DENIZENS OF THE SEA: TECHNIQUES

SPIDER-CRAB CLAW

ROCK-CRAB CLAW

CLAWS DIFFER ACCORDING TO SPECIES.

PALE BLUE GRADING TO OLIVE

CARAPACE DARK OLIVE GREEN— HIGHLIGHT SOFTLY TO ACCENT NATURAL MODELING.

YELLOWISH OLIVE (PALE) WITH SLIGHT TOUCHES OF PALE BLUE IN LIGHTER AREAS

NOTE FLATTENED SWIMMERETTES.

Blue crab (*Callinectes sapidus*). See also Plate 8.

HIGHLIGHT UPPER AREAS OF RUFFLE.

COLOR VERY DARK TO SHOW UNDERSIDE.

PALE, WASHY, BROWNISH OLIVE DEEPER TOWARD EDGE

MIDRIB DARK OLIVE-BROWN

HOLDFAST SOMEWHAT LIKE THICKENED ROOTS (NOT ALL SEAWEEDS HAVE THESE)

Alaria

SHELL GROWTH IS BASICALLY SPIRAL.

HIGHLIGHT ALONG EDGES.

NOTE UNDULATING RIDGE.

LIGHT BUFF

NOTE FAINT PATTERN.

SHADE FROM DARK TO LIGHT

Channeled whelk (*Busycon canaliculatum*)

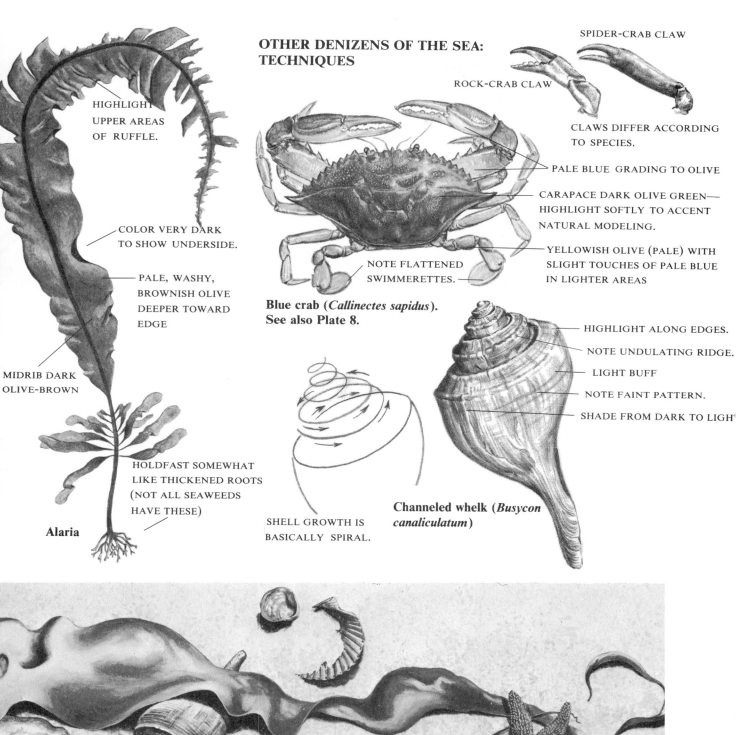

Sy Barlowe.

DEMONSTRATION: FISH IN ACTION

One of many kinds of black-and-white illustration is the wash drawing. It is far less expensive to reproduce than color, but it retains many of the same fine characteristics of a painting. The wash painting of the brown trout (*Salmo fario*) on the opposite page was created as an exercise to demonstrate this technique.

The sketch of the trout was brought to a state where darks and lights were indicated. Several reference photos were combined to achieve the animation necessary in both fish and water, as well as to make certain that anatomical facts such as the fins, mouth and gills were well presented. The horizon line was kept relatively low to emphasize the thrust of the fish upward from the water and foam. The sketch was then traced onto kid-finish Strathmore illustration board, keeping only the important lines of the sketch.

We use ivory black for the wash, preferring a superior quality watercolor because a finely ground paint will not have tiny fragments of pigment to mar the even tones we need. A plastic or porcelain palette with several deep wells is a necessity for the advance preparation of a series of graded grays, from the palest to the very deepest gray, a tone at least one step before black. The mixing of black watercolor from the tube with water in varying amounts will deepen the grays to the desired shades. Test the washes on white paper to determine how they grade.

The painting was started with the palest of the grays, which was brushed over everything that was to receive any tone at all, leaving white board where either highlights or white areas were to be. When the pale areas were dry, the medium tones of wash were applied to the parts of the fish that were closest to the upper back and underside. The foam was left in its earliest stages, while the water was darkened a bit. The next deeper shade of gray was then washed over the medium tints, incorporating a series of fine cross-hatched lines as an indication of the scaling, which is not too pronounced on trout but which acts as a texturing. By this time the complete form of the brown trout was beginning to take shape. The penciled spots on the trout's side still showed through the thinner washes quite well and would be left until later.

The progress of the painting now depended on the blending of deeper and deeper grays along the sides, inside the mouth, and on the fins. It might be good to say here that the judicious use of water and adequate drying between coats of wash are the keys to success in this medium. Too much water in each succeeding wash application will disturb the previous underpainting.

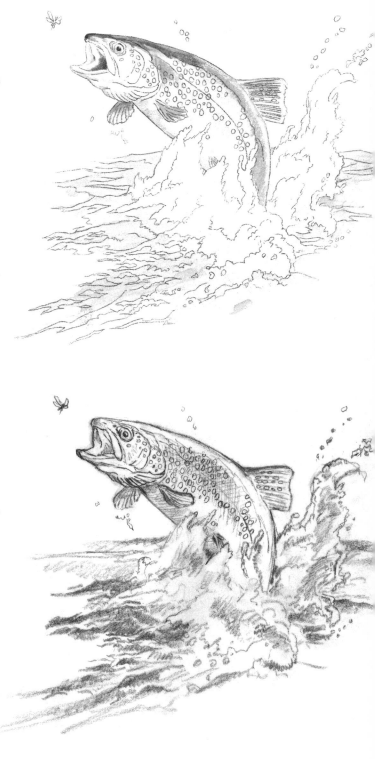

60

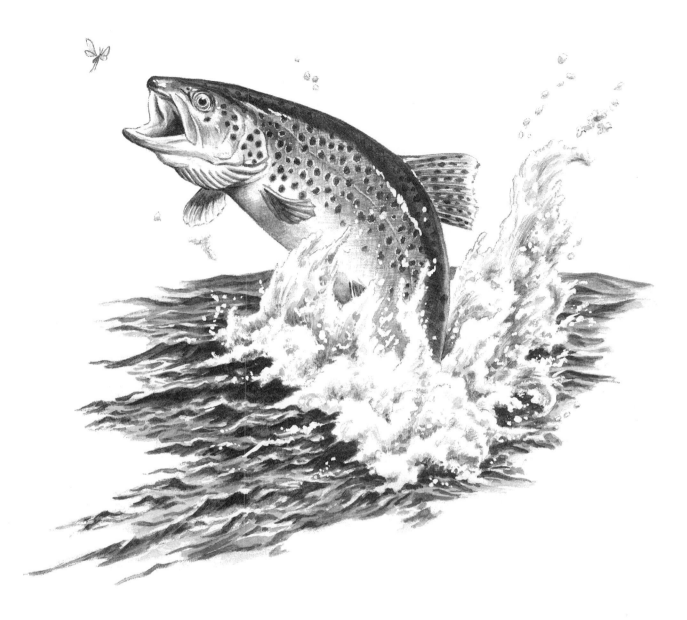

The head of the fish was the starting point to bring the painting to a conclusion. All details on the head were carefully taken care of, including the eyes, gills, nostrils, and mouth. The top of the head was darkened, and that dark tone was also brought down along the back. The dorsal fin received its spotting, while the wash was stopped just short of the edge to give the work a filmy lightness. The undersides of the gills were darkened, as were the undersides of the pectoral fins. The spots were carefully intensified to almost black and outlined with a bit of white mixed with a pale wash of gray. The small wavelets were done with very dark washes and then highlighted with pure white that was applied primarily in the foreground.

Portions of the foam were shaded slightly with medium grays and highlighted with pure white, and small independent flecks of white were added where it was necessary to enhance the edges of the foam. Bits of flying foam in pale grays were also added above the splash for even more action.

The final touches included a sparkling white highlight to the fish's back and sides to give it an appearance of being wet and very much alive.

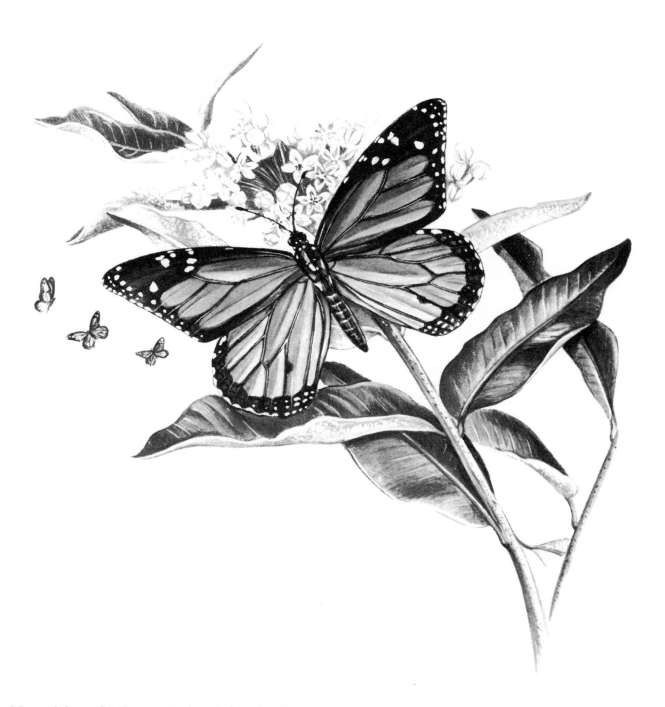

Monarch butterfly (*Danaus plexippus*). See also Plate 23

Well adapted to their environment, colorful, and interesting in their habits, insects are excellent subject matter for the nature artist. While laymen generally profess an abhorrence for insects, the artist has the ability to look at a bee, for example, and see the wonderful pollen basket (an adaptation that is a part of its hind legs) and to marvel at the symmetry of the hive. That is as it should be, for in the insect world there are also iridescent colors beyond belief and anatomical shapes worthy of any great designer. Unfortunately, the master painters have very rarely used insects as anything other than an adjunct to other subject matter—perhaps a butterfly here and there among the flowers of a still life. The one artist who apparently drew and painted insects for their own sake was Dürer. His study of stag beetles is lively and discerning, demonstrating what can be done with this subject.

Much of the insect drawing and painting done today is prepared for book illustration, for children's books, textbooks, technical tomes, and, occasionally, popular magazines or newspapers. We have many times been called upon for this type of illustration and find the fascination with the subject half the fun of doing it.

The first aspect of an assignment that an artist needs to clarify is the Latin name of the insect in question. Colloquial names seem to abound in this area of natural science. A good example of just such vernacular use is *Corydalis cornuta,* or dobsonfly. According to one source, the common names used for this insect on Rhode Island alone are dobsons, crawlers, clipper, water grampus, bogart, crock, hell devils, flip-flaps, alligators, Ho Jack, snake doctor, dragon, and hell diver. With this as the inevitable pattern, it is wise when given the common name to obtain the Latin name as quickly as possible, since Latin is the universal tongue of the scientist. Even so, problems may arise, as sometimes even Latin terminology is changed at such a rate as to render obsolete last week's nomenclature. Check any puzzling name with the nearest museum entomologist; experts are often quite willing to help you solve your dilemma. Don't go ahead with an assignment if there is any uncertainty about species, subspecies, or genera.

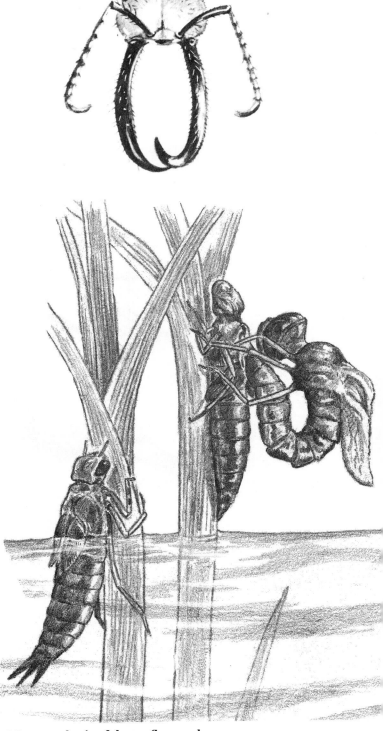

Head of army ant

Metamorphosis of dragonfly nymphs

Acquiring specimens to work from isn't as difficult as it may seem. For those that are not squeamish, there are books about insect collecting that clearly describe the procedure. However, it is not necessary to collect your own insects, as many biological supply houses have specimens and generous lists in their catalogs to choose from. In some areas small, delightful stores that sell many natural-science products, including butterflies and other insects, have sprung up of late. These are well mounted (pinned), and you can purchase them rather inexpensively. One warning—you will never be able to choose just one insect, since the shapes and colors will happily distract you into buying many more than you originally intended. This will be especially true when you are confronted with a myriad selection of gemlike beetles and brilliant, exotic butterflies.

The techniques for rendering insects can vary from pen-and-ink line or stipple to full-color, depending on the need of the moment, but even the most astute artist will have to think first of accuracy; the insect family has a tremendous number of species and subspecies. The smallest detail is often of great importance. Insects can become the forte of a meticulous artist. The textures, from the pitted beetle wings to the delicate venation in the wings of a damselfly, are sure to be a challenge. The artist who works in color will find the insect world one of truly exquisite possibilities. Not only the entire butterfly clan but also the tiniest hover flies can shimmer with iridescent blues, purples, and greens. Tiger beetles or some of the remarkable tropical insects that mimic orchids and other plants can produce superb compositions when combined with suitable habitats.

If you have unlimited patience for small detail and are the kind of person who delights in recreating realistically the leg hairs of a beetle and breathing life into a butterfly's eye, then this subject area is for you. The following pages deal with comparative anatomy as it applies to insects, as well as some of the techniques that are particularly helpful for this type of illustration.

Grasshopper head

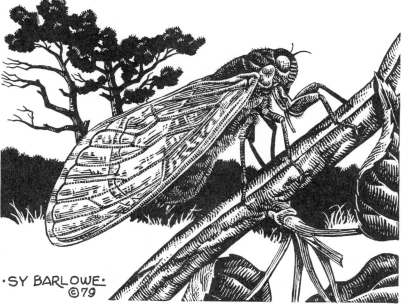

This illustration of the cicada (*Magicicada septendecim*) is a scratchboard drawing prepared as part of Sy Barlowe's "Nature Watch" series for *The New York Times*.

ANATOMY OF INSECTS

Insects as a group outstrip all other animal life in numbers. There are thought to be at least sixty-five thousand species in the world. Categorized scientifically in the class Insecta they are distinguished from other similarly segmented animals in that they all have six legs and are divided into twenty-seven different biological groups known as orders, some of which are flies and mosquitoes, ants and bees, wasps, beetles, butterflies and moths, and wingless bugs.

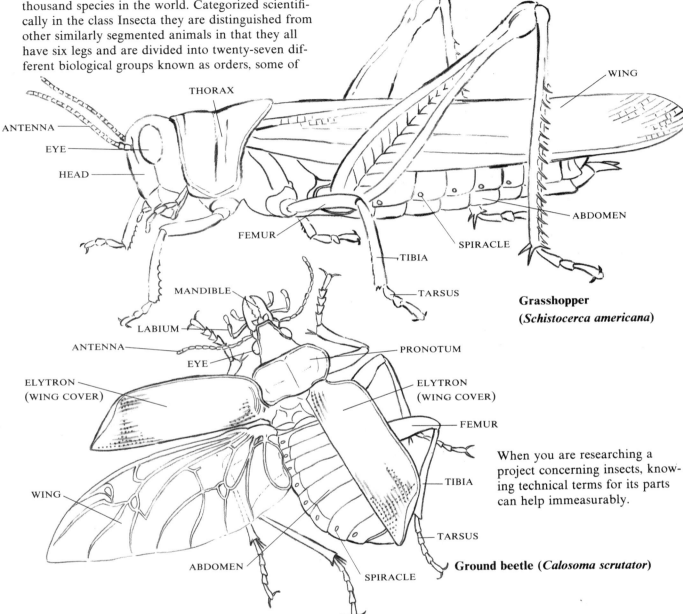

Grasshopper
(*Schistocerca americana*)

When you are researching a project concerning insects, knowing technical terms for its parts can help immeasurably.

Ground beetle (*Calosoma scrutator*)

Insects all have bodies composed of an exoskeleton made of a chitinous material that is somewhat akin to that of human fingernails. Their bodies are segmented into a head, thorax, and abdomen. Three pairs of legs protrude from the underside of the thorax. On winged insects there are also two to four wings on the dorsal side of the thorax. The head has a complex system of mouth parts, compound (multi-faceted) eyes, and a pair of sensitive antennae. A powerful magnifying glass or a small microscope is a very useful piece of equipment for this type of illustration. Once you look at insects under magnification you will be hard put to doubt nature's technical artistry.

65

Try to work from specimens as often as possible. Unless some rare, unobtainable species is required, it is always best to have a model. Even though the shape of the insect is the primary concern, never overlook the step of counting the number of segments in the antennae and the tarsus (usually two to five), and the number of abdominal rings, if they are obvious. Careful examination of the insect's underside will help you to place the legs properly on the thorax, and a magnifying glass will reveal the eyes and mouthparts. Important differences in species are sometimes apparent here. Fortunately, the majority of insects are rigidly symmetrical. Once you have all the "counts" of one side on paper, you have a shortcut that can be used when you draw the other half.

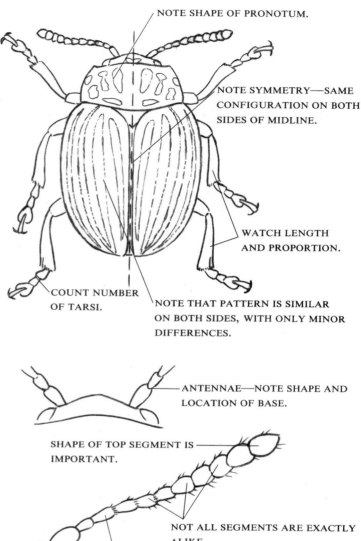

NOTE SHAPE OF PRONOTUM.

NOTE SYMMETRY—SAME CONFIGURATION ON BOTH SIDES OF MIDLINE.

WATCH LENGTH AND PROPORTION.

COUNT NUMBER OF TARSI.

NOTE THAT PATTERN IS SIMILAR ON BOTH SIDES, WITH ONLY MINOR DIFFERENCES.

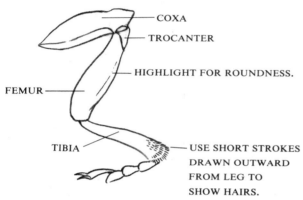

COXA

TROCANTER

HIGHLIGHT FOR ROUNDNESS.

FEMUR

TIBIA

USE SHORT STROKES DRAWN OUTWARD FROM LEG TO SHOW HAIRS.

Draw all the details of one side of the dorsal view of a beetle, fold the tracing paper along the midline of the full drawing, and trace the initial half on the opposite side of the line. Unfold the paper, and you have a fully symmetrical drawing. To make it more lifelike, change the position of a leg or two.

ANTENNAE—NOTE SHAPE AND LOCATION OF BASE.

SHAPE OF TOP SEGMENT IS IMPORTANT.

NOT ALL SEGMENTS ARE EXACTLY ALIKE.

COUNT SEGMENTS; NOTE HAIRS.

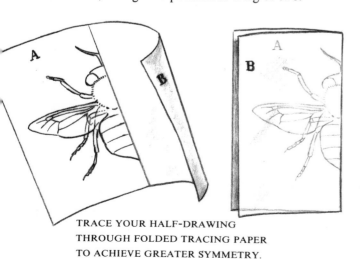

TRACE YOUR HALF-DRAWING THROUGH FOLDED TRACING PAPER TO ACHIEVE GREATER SYMMETRY.

Many insects have beautiful designs. Whether you are working in black-and-white or in color, you should strive to keep the pattern from looking as though it were painted on. Integrate the markings into the shading of your insect, making them darker where the darkest shadows are and almost invisible at the point of highest highlight. Although there will be minor differences in the pattern of design of a species, it is of great importance to follow your research material; any change in the pattern might inadvertently produce a drawing of a different or nonexistent species.

66

METAMORPHOSIS

The young of insects constitute a large part of insect illustration. Many times it is necessary to do a drawing or painting of not only the insect but its young and eggs as well. Because the young in most cases do not resemble the adults, additional research is often essential. Along with finding material about the young insect, and perhaps the eggs as well, we have to be sure of its living habits, which can be quite diverse. The dragonfly larva, for example, spends its carnivorous youth living underwater in a pond or stream.

Every illustrator of insects should be aware of how insects metamorphose. Was your subject born as a tiny replica of the adult, or did it move through complex stages from larva to adult?

Being equipped with simple facts gleaned from books on entomology will prevent you from making embarrassing mistakes. But more than that, the knowledge will bolster your interest in the subject and make your work plausible.

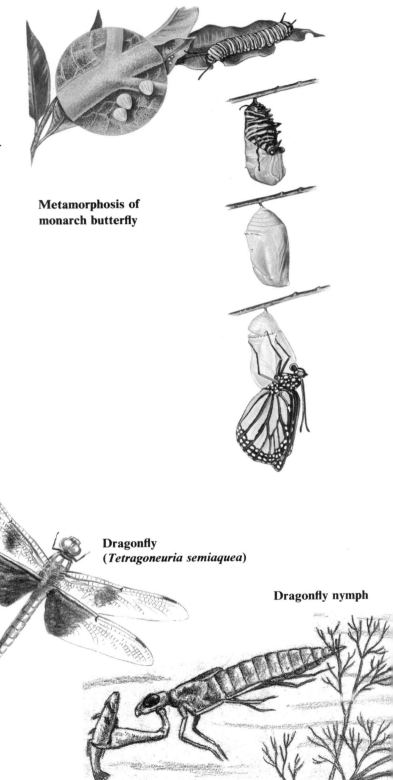

Metamorphosis of monarch butterfly

Harlequin bug
(*Murgantia histrionica*)

NOTE PATTERN CHANGE IN MATURE BUG.

NYMPHS ARE SIMILAR TO ADULTS.

SHADE AS YOU WOULD A CYLINDER.

Eggs

Dragonfly
(*Tetragoneuria semiaquea*)

Dragonfly nymph

67

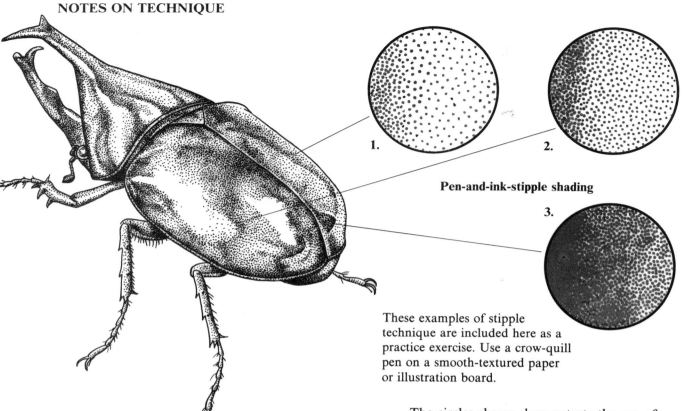

Pen-and-ink-stipple shading

1.

2.

3.

Rhinoceros beetle (subfamily Dynastinae)

There are many mediums and techniques that can be applied to the illustration of insects, and all are worth attempting as you go along. One of our favorite methods is pen-and-ink stipple drawing. This technique has several advantages that make it excellent for illustrating insects, not the least of which is that it forces the artist to carefully observe the subject matter.

Pinned specimen

CORK

These examples of stipple technique are included here as a practice exercise. Use a crow-quill pen on a smooth-textured paper or illustration board.

The circles shown demonstrate the use of stipple in its most basic application. The blending of the stipple dots to suggest roundness in the drawing is nothing more or less than a matter of using more dots in the darker areas and less and less in the lighter areas, with the lightest portions having no stipple whatsoever. Work in a precise fashion, placing one dot at a time. The more evenhanded the approach, the finer the blending will be. Of course, in extremely dark areas the dots must overlap in order to achieve this density. For a full roundness, the outline of the drawing should be incorporated into any shadow areas as much as possible by bringing the stipple right up to the line as is shown here. To determine whether your stipple is even and blending well, squint at the drawing. If there are tiny uneven white spaces, a few well-placed dots should do the trick.

Not all insect drawings need outlines. Experiment with just light and dark effects without an outline. This usually works better if the drawing is a large one; a small drawing will lose necessary definition in its minute detail.

HEADS

The heads of insects can vary considerably even within a species. Antennae, size, shape and placement of eyes, and mandibular construction may all differ. We need to be very accurate here, for besides confirming the species or subspecies, the rendering of these features will also help to capture the essential characteristic of the "breed." A magnifying glass or jeweler's loup for the larger specimens and a microscope for the smaller ones are practical necessities. Patience leads to discovery, and you will find it gratifying to check your drawings against entomology books and discover agreement on all points. The illustration on the right is divided to show the use of both pen-and-ink and color for further practice.

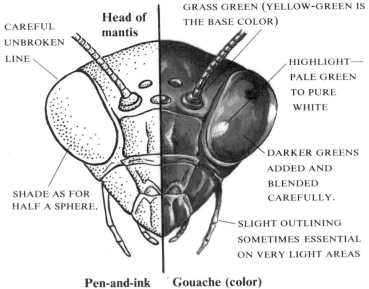

Head of mantis

CAREFUL UNBROKEN LINE

GRASS GREEN (YELLOW-GREEN IS THE BASE COLOR)

HIGHLIGHT—PALE GREEN TO PURE WHITE

DARKER GREENS ADDED AND BLENDED CAREFULLY.

SHADE AS FOR HALF A SPHERE.

SLIGHT OUTLINING SOMETIMES ESSENTIAL ON VERY LIGHT AREAS

Pen-and-ink Gouache (color)

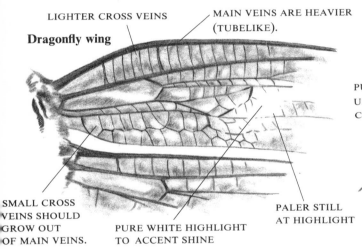

Dragonfly wing

LIGHTER CROSS VEINS

MAIN VEINS ARE HEAVIER (TUBELIKE).

SMALL CROSS VEINS SHOULD GROW OUT OF MAIN VEINS.

PURE WHITE HIGHLIGHT TO ACCENT SHINE

PALER STILL AT HIGHLIGHT

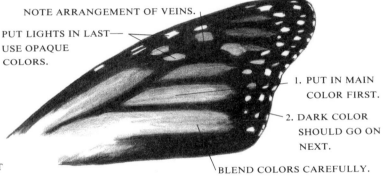

Method for working patterns

NOTE ARRANGEMENT OF VEINS.

PUT LIGHTS IN LAST—USE OPAQUE COLORS.

1. PUT IN MAIN COLOR FIRST.

2. DARK COLOR SHOULD GO ON NEXT.

BLEND COLORS CAREFULLY.

WINGS

Drawing the venation of an insect's wing will require the use of your finest pens or brushes. The development of a light-handed touch is essential. You will want to preserve enough accuracy to pinpoint the species, but only in a strictly scientific drawing will you need to draw every vein in its place. Experience will teach you how to eliminate some of the venation

while still implying it is there. With butterflies, the venation often seems to play an integral part in color distribution on the wings. Unlike that of the more transparent wings of some insects, the venation on the butterfly wing should always be a part of the pattern and design of the drawing.

LEGS

It is in the careful handling of minute detail that the work of the dedicated illustrator of insects is immediately recognizable. He must be able to see and reproduce convincingly even the hairs on the leg of a flea.

The drawing at left indicates the direction in which the pen- or brush-strokes have to be pulled in order to produce a hair that is properly thick at the base. Hairs always taper to a fine tip, and by pressing just a bit harder at the beginning of the stroke, you should be able to produce a hairlike line with no difficulty.

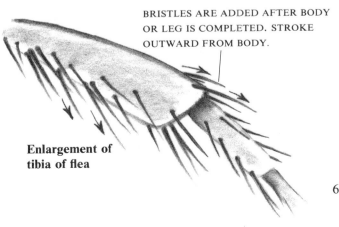

BRISTLES ARE ADDED AFTER BODY OR LEG IS COMPLETED. STROKE OUTWARD FROM BODY.

Enlargement of tibia of flea

ANATOMY OF BUTTERFLIES AND MOTHS

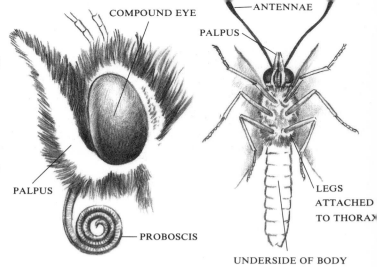

Butterfly anatomy

Butterflies, "flying flowers," are gentle and harmless, and add a decorative touch to the summer garden. They are the end product of a complex metamorphosis. As caterpillars, they are unfortunately often destructive to plant life, but they too are beautiful in their way. For protective coloration caterpillars may be dull or brightly colored, hairy or smooth in appearance. They have two kinds of legs: two to five pairs of rounded pads called prolegs on the abdominal section, and two or more pairs of jointed ones in the forward (thoracic) section. There are often two body segments at the caterpillar's rear that have no legs whatsoever.

All this is mentioned in order to make you aware of the necessity for keen observation. Their physical differences, both minor and major, are of great importance in identifying species.

There are not many times when you will need a really definitive closeup of a butterfly's head, but you should know exactly what it looks like from different angles so that you will understand eye and antenna placement and become acquainted with the position of the curled tongue. Check the illustrations above against your own specimen. You will find that butterfly antennae vary in shape, depending on species. Some have a minute club at the end, while others are recurved or hooked or vary in other ways. Here, too, only by closely observing your specimen will you be able to be sure that you have the right details for the species you are illustrating.

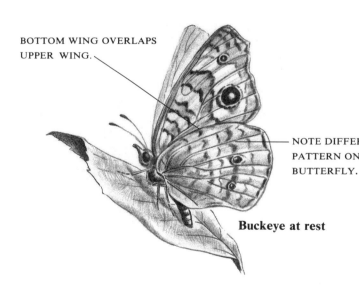

Buckeye at rest

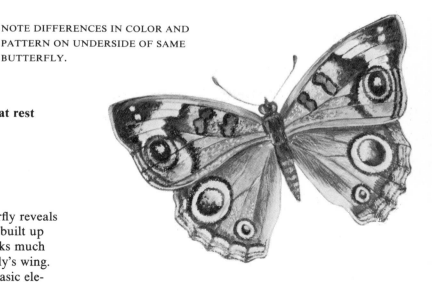

Buckeye
(*Precis lavinia*)

Using a microscope on the wing of a butterfly reveals that its color consists of overlapping scales built up shingle-style on a transparent base that looks much like the substance that makes up a dragonfly's wing. Although shape and pattern are the most basic elements of butterfly identification, much more is told by the venation on the wings; it never fails to separate the most blatant lookalikes.

FORESHORTENING

To illustrate a butterfly or moth in a lifelike flight position, first draw it flat, in its dorsal view, on heavy tracing paper. Add the fully shaded pattern and ven-

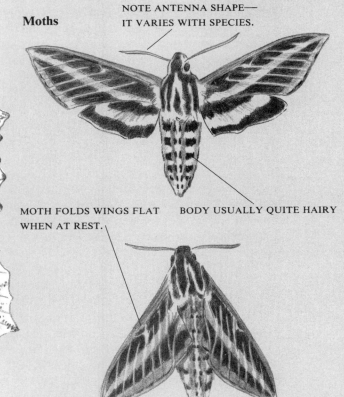

Moths

NOTE ANTENNA SHAPE— IT VARIES WITH SPECIES.

MOTH FOLDS WINGS FLAT WHEN AT REST.

BODY USUALLY QUITE HAIRY

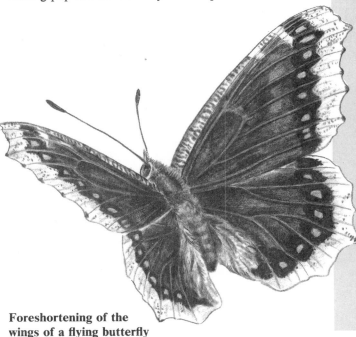

Foreshortening of the wings of a flying butterfly

ation to both the back and front of the drawing, then clip the sketch out with a small scissors. Fold the wings to the desired flight position and it becomes an excellent model for drawing the pattern and venation in perspective.

MOTHS

The order Lepidoptera includes both butterflies and moths. If the creature flies at night and rests with its wings folded back, it is very likely a moth. The moths' camouflage is truly unbelievable. They are beautiful to draw or paint, a challenge for anyone who dotes on intricate detail. Moths go through the same metamorphosis as butterflies, but as caterpillars they are usually more destructive. The antennae are generally feathery in shape and the bodies often clothed in dense hair.

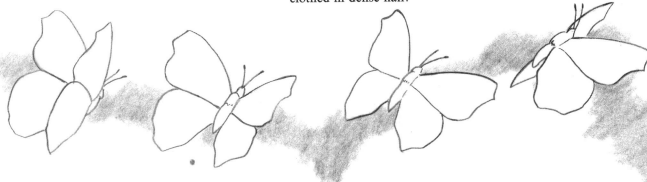

Butterfly flight

DEMONSTRATION: INSECT IN HABITAT

On one occasion when we were commissioned to illustrate a book that was to have both black-and-white and color pages, we opted for pencil as the black-and-white medium. We could have chosen pen-and-ink, black-and-white watercolor wash, or scratchboard, but pencil drawings seemed to have soft characteristics that would not dominate the text, while the controlled technique of this kind of drawing would be well able to balance the color plates.

The drawings were done on #172 Bainbridge board. This provides a surface that pencil will cover smoothly, and we thus avoided a sketchy appearance that would have been out of keeping with the general feel of the book.

Only one grade of pencil was chosen—the HB. It has good darks when needed, yet allows for a well-sharpened, noncrumbling point that in this drawing was important for outlining the plants, the bee's legs, and the antennae. A harder pencil—a 2H, for example—would have been impractical, presenting drawing difficulty by digging into the board's surface and by being hard to erase.

Of course, the choice of the honeybee (*Apis mellifera*) was the author's, and we scrambled for suitable material to fill out the projected double spread. The bee and the flower were to be the major illustration in a life-cycle group. We used Canterbury bells as the flowers because of their graceful habit and the fact that the shape of its open blossom and fine leaves on the upright stem would fill out the allotted space around the text quite nicely. The bee was a garden casualty.

The original sketch was drawn on heavy tracing vellum and was then prepared for transfer to the illustration board. The back of the sketch was blacked with a soft pencil (2B) and afterward rubbed lightly with a finger to remove excess pencil dust. With its back surface thus transformed into carbon paper, the sketch was then positioned, face up, on the illustration board and taped in place. We use a 7H or 8H pencil for tracing through because it produces a fine, sharp outline on the working surface.

1. After the finished sketch was traced onto the illustration board, the resulting outlines were strengthened with the HB pencil.

2. The fuzzy appearance of the bee was accomplished with short pencil strokes pulled outward from the body of the insect. Bees are quite hairy; the head, thorax, and abdomen are covered with fine hairs. The shading of the hairy areas was accomplished with the same short strokes, overlapped to darken the shadow areas.

3. The smoother texture of the bee's eyes, legs, and antennae was more evenly drawn, with the highlights carefully planned in advance. It is not a good idea, when doing pencil drawings, to rely on erasure for highlights in such small and delicate areas, as erasing would no doubt disturb the good pencil work already completed. The legs on the far side of the bee were made paler and less distinct in form in order to give a necessary three-dimensional illusion.

4. The soft, uncomplicated shading of the flower was the result of more even pencil toning and not too many heavy shadows, thus achieving as smooth a texture as possible. The strokes were kept under full control, with only a small section worked at a time.

5. Before the final drawing was sprayed with workable fixative, a few more darks were put in strategically for emphasis and to make certain that the drawing would not lose its sharpness in reproduction.

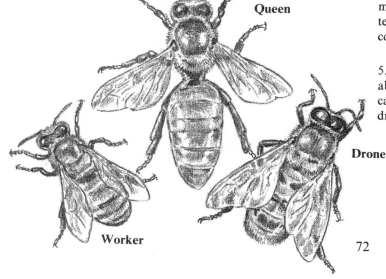

Queen

Drone

Worker

72

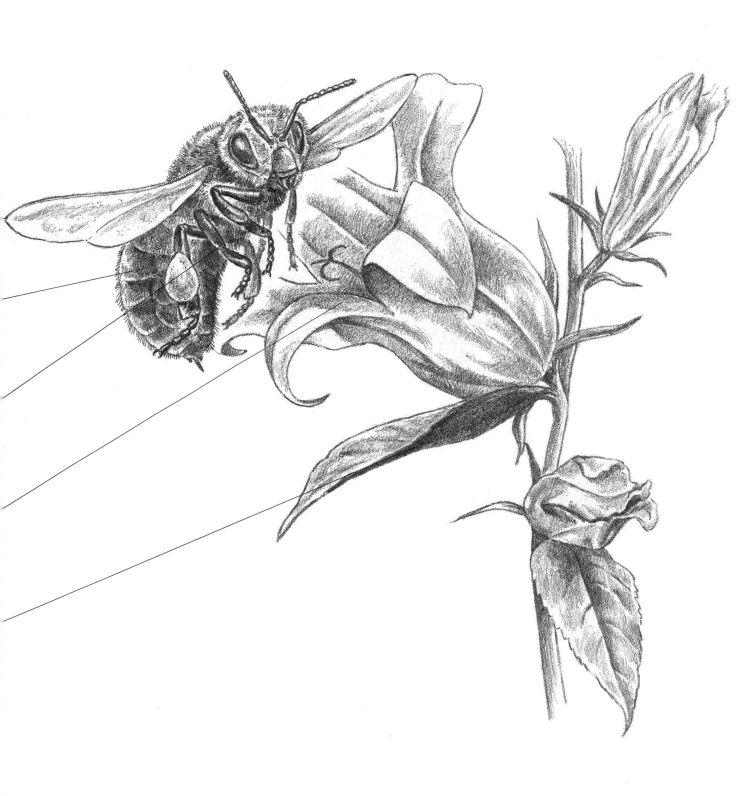

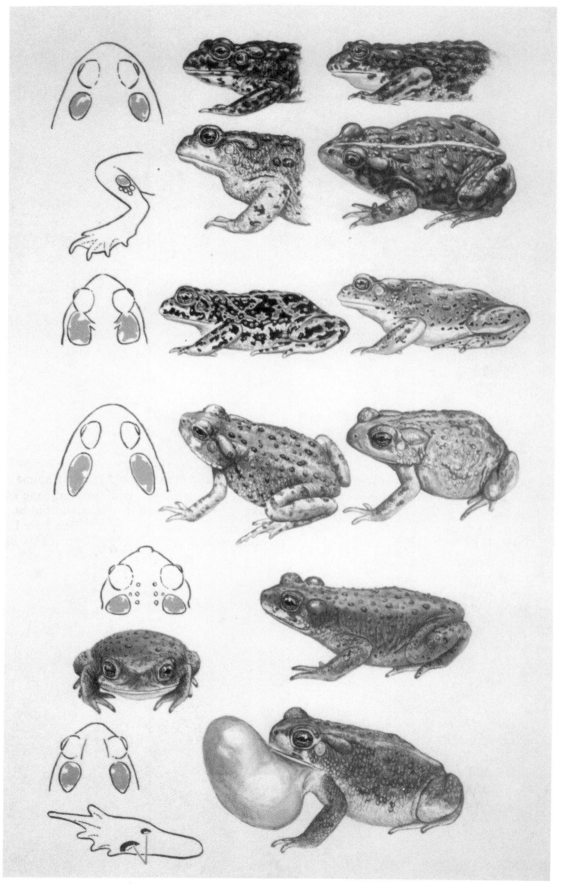

Toads. Page of illustrations for an identification guide

REPTILES AND AMPHIBIANS

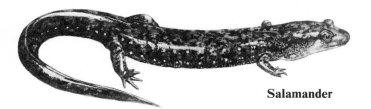

Salamander

The gemlike colors, patterns, and scalations of reptiles and amphibians are so magnificent that a close examination must certainly eradicate all feelings of aversion. As illustrators we have always looked upon snakes and lizards with the admiration of the jeweler for a finely crafted piece of jewelry.

Fascination with reptiles and amphibians can grow steadily with the study of their habits. They may not be as endearing as the warm-blooded furred and feathered creatures, but for the artist they provide a tremendous challenge to his skill.

In drawing and painting the numerous members of these biological groups, you must take full account, in the interest of accuracy, of all the scale patterns, warts, protuberances, and other details of your chosen model. Each species of snake, toad, turtle, salamander, or lizard has its own special characteristics. This patient, plodding kind of work is not for everyone, but there are some artists who genuinely love such tasks.

Of course, there is more to a snake, frog, or lizard than its outward appearance. Each is a complex living creature with an interesting life cycle, and all often live in environments that provide excellent material for the artist to work with. The illustrator dealing with frogs and toads must be able to paint or draw the appropriate varieties of foliage as a background in which to place his subject matter. This, as well as a foundation in the techniques of executing rocks, water, and sand is of great importance. Beyond that, everything will depend on personal inquisitiveness and research.

Time spent at a good museum or at a reptile house at the zoo will certainly prove quite valuable. Though the animals presented there are not always in their typical habitats (mostly because

such conditions would make viewing them well-nigh impossible), they are usually sufficiently well housed to permit sketching and photographing. A good selection of photographs and sketches will help you immeasurably to achieve more natural and lively positions. Many local pet shops have collections of reptiles and some amphibians and do not discourage old-fashioned browsing. There are also many attractive books on the subject that will help you add to your general knowledge.

Try to get as close to your subject as you are able in the fullest sense of the word. Holding a harmless snake, lizard, or turtle in your hand can tell you many things; that the animal is shiny, for instance, but not a bit slimy. This is important information, as texture is a large part of the story in painting and drawing cold-blooded animals. The scales of a snake, you will discover, have a keel-like ridge along them in some cases but not in others; the tiny toes of the tree frog have little pads on the ends that will remind you of suction

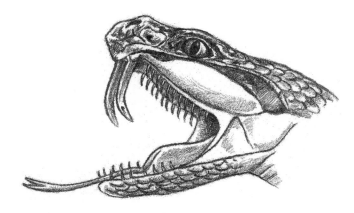

CUTAWAY OF RATTLESNAKE
HEAD SHOWING POISON SAC

cups, and the length of the claws and the eye color of some turtles indicate their sex.

Techniques for rendering reptiles and amphibians are as diverse as the wide range of subject matter and your particular preference. Because they are such a colorful tribe, it is not out of order to say that you would do well to experiment in some color medium. If you have watercolor in mind, you will need a bevy of small brushes to pick up the necessary detail. As a precautionary measure, all of your preliminary work should be carefully plotted sketches; these will provide protection against confusion when you begin to render scale structure in your painting medium. Painting scales is not as difficult as it may appear, but it is a process that requires skill, which is itself born of practice and patience.

As a nature illustrator you will find that assignments concerning reptiles and amphibians invariably turn up with greater frequency in biology books and children's books, but the beauty of these all too often maligned animals could easily be channeled into many other kinds of artistic undertakings. Perhaps the following pages will help define the possibilities that could be explored. A simple way to distinguish between reptiles and amphibians is to remember that if the creature has scales or plates on its body and claws on its toes, it belongs to the class Reptilia, but if its skin is moist and devoid of scalation and its toes are clawless, it is an amphibian (class Amphibia). Frogs, toads, salamanders, and newts are amphibians, but snakes, lizards, turtles, and crocodilians are reptiles.

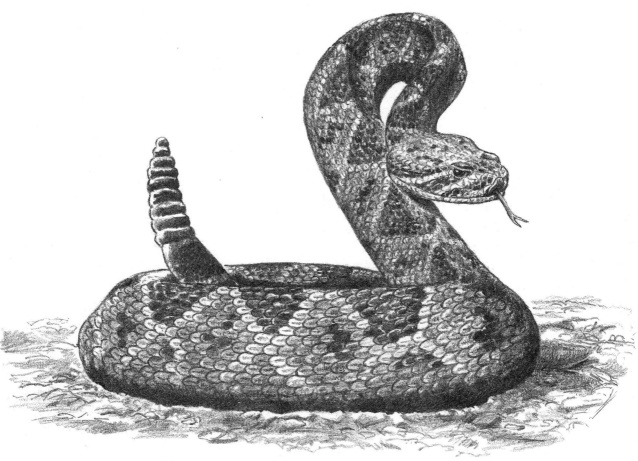

Eastern diamondback rattlesnake
(*Crotalus adamanteus*)

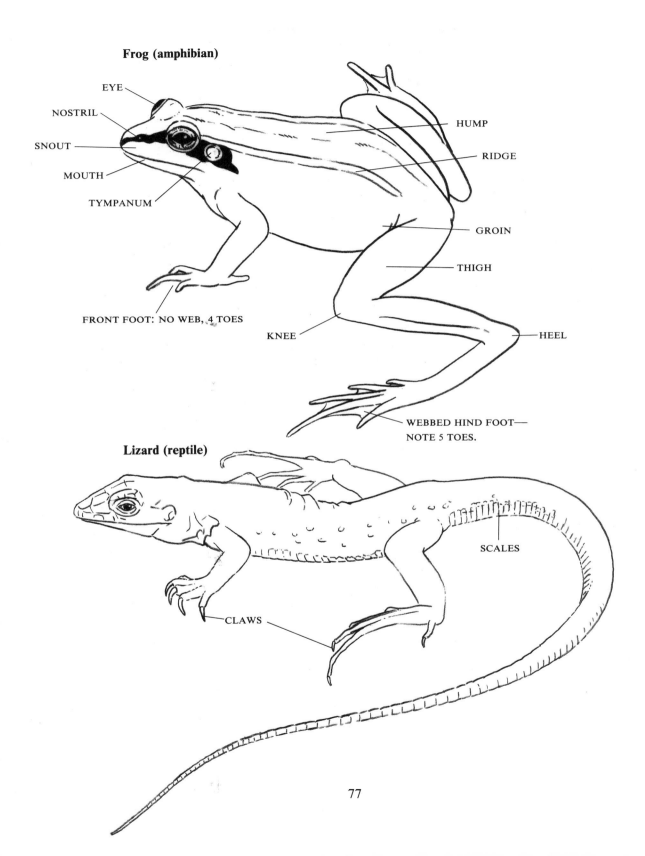

Frog (amphibian)

EYE

NOSTRIL

SNOUT

MOUTH

TYMPANUM

HUMP

RIDGE

GROIN

THIGH

FRONT FOOT: NO WEB, 4 TOES

KNEE

HEEL

WEBBED HIND FOOT—
NOTE 5 TOES.

Lizard (reptile)

SCALES

CLAWS

77

SCALES, SKIN TEXTURES, AND PATTERNS

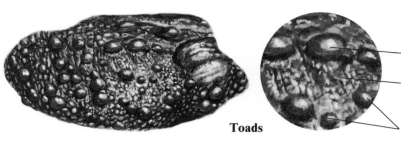

Toads

FOLLOW SPECIMEN FOR ACCURATE PLACEMENT OF WARTS.

HIGHLIGHT WARTS TO ACHIEVE ROUND EFFECT.

NOTE THAT TEXTURE DERIVES FROM MIXTURE OF SMALLER AND LARGER WARTS.

LIGHTING MUST REMAIN CONSISTENT.

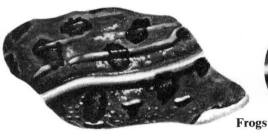

Frogs

WASH IN OVERALL COLOR.

NOTE WHAT HAPPENS TO PATTERN AS IT OVERLAYS RIDGES.

PATTERN MUST BE CONSISTENT WITH SPECIMEN REGARDING COLOR AND DISTRIBUTION.

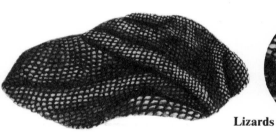

Lizards

DARK COLORS IN SHADOW AREAS SHOULD GIVE HINT OF SCALES.

PATTERN OF SCALATION WILL APPEAR RAISED IF MINOR HIGHLIGHTING IS DONE ON EACH SCALE.

NOTE SCALE SHAPES—SPECIES DIFFER.

Snakes

SMOOTH SCALES: SHAPES VARY.

COLOR MARKINGS FORM DISTINCTIVE ALL-OVER PATTERNS—ADD AFTER ALL SCALES ARE DRAWN.

NOTE THIN HIGHLIGHT ALONG SCALE EDGES—COLOR SHOULD GRADE SLIGHTLY TOWARD EDGES.

Snakes

KEELED SCALES: NOTE KEEL OR RIDGE SHADOW—MAKE KEEL PROMINENT. FOLLOW SPECIMEN FOR COLOR DISTRIBUTION.

CHARACTERISTICS OF REPTILES AND AMPHIBIANS

Costal grooves (which should be counted) are a basic characteristic of all kinds of salamanders except newts. Eyelids, four toes on the front feet and five on the back feet, and no claws are other distinguishing features.

SALAMANDERS

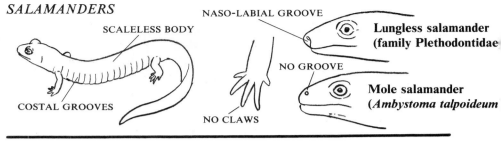

Frogs have moist skin. Some have a pair of ridges, varying in length according to species, on either side of the back. Toads (with some exceptions) have dry skin and a pair of thick paratoid glands above the tympanum. Both have well-formed eyelids and small nostrils. Foot webbing and toe shape are characteristics used in identifying species.

FROGS AND TOADS

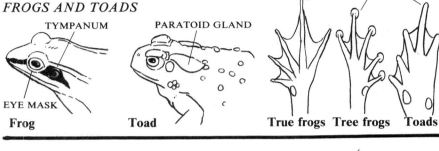

Lizards have well-developed eyelids and earholes, as well as bodies covered by keeled, smooth, or granular scales. Note scale direction and pattern, the number of toes on the front and back feet, the length of the tail, the size of the head, and eye color. The shape of the head scales will also help you to determine the species, always keeping in mind that such scales should be rendered correctly.

LIZARDS

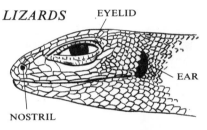
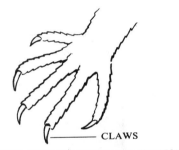

Snakes' eyes are lidless. And bear in mind that it is vital that the head shape be rendered accurately, since small differences in configuration are often all that distinguish one species from another. A close scale count is necessary in order to achieve an adequate drawing of the pattern throughout. The shape of the head scales helps to define the species.

SNAKES

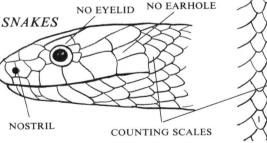
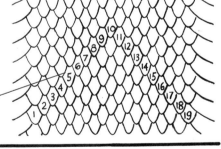

The specific characteristics of a turtle's shell help to identify the species. Note the shape of the scutes (plates) on the carapace and plastron, and slowly integrate their patterns as the work progresses. The clawed toes and eye color are species and sex determinants. Eyes are lidded. Carefully draw the shape and size of neck and leg scales.

TURTLES

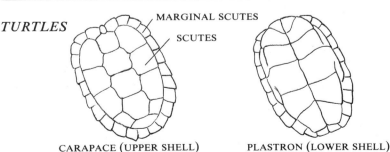

LIFE CYCLES OF REPTILES AND AMPHIBIANS

The young of reptiles surprise the uninitiated because it seems incongruous that anything other than a bird would come out of an egg. But when we recall the biological ancestry of birds the pieces fit the puzzle and all appears right with the world of nature.

The basic difference between bird and reptile eggs is that while the bird's eggshell is hard and firm, that of the reptile is leathery and sometimes covered with spicules. To paint or draw the eggs of reptiles is a matter of texturing them differently so that their final appearance is like that of soft vinyl.

The young, though looking much like the adults, are either spotted or bear some other characteristic of youth. The eyes may be somewhat larger (and consequently innocent-looking) and the head proportionally also a little larger. The scalation is already quite evident in infancy. Research your subject when trying to match the young of reptiles with the adults, because though differences may be slight, they are vital in identification.

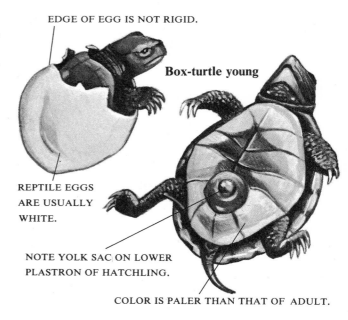

EDGE OF EGG IS NOT RIGID.

Box-turtle young

REPTILE EGGS ARE USUALLY WHITE.

NOTE YOLK SAC ON LOWER PLASTRON OF HATCHLING.

COLOR IS PALER THAN THAT OF ADULT.

If your illustrations require identifying arrows, a well-stocked art-supply store may be able to supply ready-make transfers. If you paint the arrows, make sure all are the same size.

LARVAE BECOME ADULTS AND LEAVE WATER.

ADULT

ADULTS RETURN TO WATER TO BREED.

LAND

WATER

Life history of a salamander

COURTSHIP

EGG MASS

FEMALE ACQUIRES SPERMATOPHORE.

MALE DEPOSITS SPERMATOPHORE.

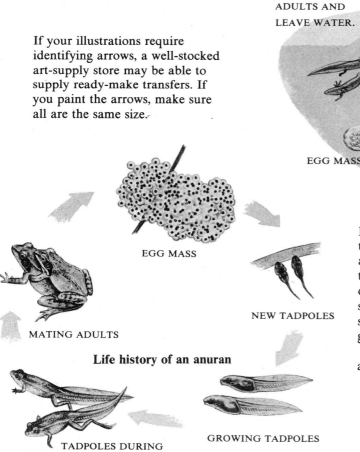

EGG MASS

NEW TADPOLES

MATING ADULTS

Life history of an anuran

TADPOLES DURING TRANSFORMATION

GROWING TADPOLES

Depicting the amphibian's life cycle is more complex than portraying that of the reptile. The dual life that amphibians lead in the water and on land makes their progressive development—and hence your drawing of the cycle—more complicated. Before starting such a project, you should investigate each stage of the animal's development. The illustrations given here detail the progression of life-cycle.

Make sure that the various stages you show are appropriate to the species you are illustrating.

TRANSPARENT, PALER COLOR TONES WASHED IN

Frog tadpole

REPTILES AND AMPHIBIANS IN HABITAT: TECHNIQUES

OLIVE GREEN AND BROWNS ARE
BASIC COLORS HERE.

DARKER LOG RECEDES INTO
BACKGROUND.

LIGHT BRANCH ACTS AS CONTRAST
AND BRINGS EYE TO POINT OF
INTEREST.

The gloom of a swamp can be represented by using muted greens (olive, terra verte, chromium-oxide green), grays, and browns. Lighting effects should be muted except where the tops of the trees begin to touch the sky.

WARM YELLOWS, ORANGES,
BROWNS GIVE SUN-BAKED
APPEARANCE.

WATCH SNAKE PATTERN—DRAW
ACCURATELY FOR SPECIES NATIVE
TO HABITAT.

STIPPLE SAND TEXTURE; RETAIN
CONTOURS AND RIDGES FOR
INTEREST.

Colors for a desert setting are usually light, especially sun-drenched yellows, Indian yellow, and warm sienna. All shadows are strong, tinged with mauve or blue. The colors in general are brilliant and raw in both animals and plants.

PAINT DARKEST TONES FIRST.

SUPERIMPOSE OPAQUE LIGHTER
GRASSES.

All nature compositions are enhanced by colors that evoke an appropriate emotional response. For most of us, certain colors automatically bespeak certain geographical settings. We all subliminally play this game of color association. Apply it consciously to your next project, whether it is a boa constrictor in a jungle background, or a toad squatting under a mushroom on the forest floor.

SHADOW IS PAINTED WITH PAYNE'S
GRAY AND BLACK.

STIPPLE RANDOMLY WITH BRUSH
TIP TO DEFINE TEXTURE.

ROCK TEXTURES DIFFER; COLOR
OFTEN KEY TO TYPE OF
ROCK—HERE GRAY PLAYS UP
COLOR OF SALAMANDER.

ADD GOOD, STRONG WHITE
HIGHLIGHT FOR MOIST
APPEARANCE.

**Mountain salamander
(*Desmognathus ochrophaeus*)**

DEMONSTRATION: AMPHIBIAN IN A CHILDREN'S BOOK ILLUSTRATION

What could be a more delightful subject than the leopard frog (*Rana pipiens*)? It is spotted like an enameled toy and has an extremely lively expression. This illustration (shown in color in Plate 24) is an example of nonscientific art that retains the integrity a book for children deserves. The sketch was done to allow for a text area, and the hind leg was brought down for interest as well as to display the frog's toes and webbing. Hygrophorus mushrooms were chosen for the background because they are charming in shape, their size was helpful to the composition, and they provided a good contrast of color to the greens, browns, and blacks of the frog.

After the initial drawing was traced on Bainbridge #80 kid-finish illustration board, the first gouache colors were washed in with a #2 Winsor & Newton watercolor brush. This palette consisted of burnt umber, burnt sienna, yellow ocher, Chinese orange, lemon yellow, cadmium yellow deep, viridian green, olive green, and white. The greens on the frog, viridian mixed with a bit of olive, were applied first, followed by burnt umber for the darks, to set the pattern of shading. The spots were then established but not refined into finished form as yet. Light areas were left unpainted at this point. The mushrooms were given their first tint of lemon yellow as an underpainting to the deeper orange that was to be added later. The gills and stems were left unpainted, while the shadow areas were lightly tinted with burnt umber. The foreground grasses were washed in, in shades of yellow ocher, cadmium yellow deep, and lemon yellow.

With detailed photographs near at hand, the gouache was gradually thickened as layer upon layer of color was painted over the original base colors. Either white was added as a thickening agent or the color was used almost as it came from the tube.

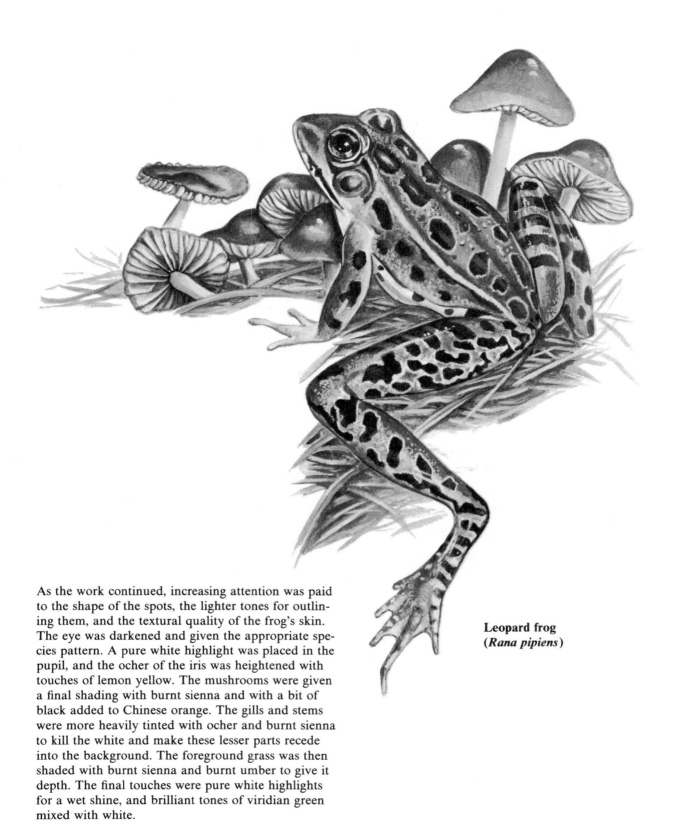

Leopard frog
(*Rana pipiens*)

As the work continued, increasing attention was paid to the shape of the spots, the lighter tones for outlining them, and the textural quality of the frog's skin. The eye was darkened and given the appropriate species pattern. A pure white highlight was placed in the pupil, and the ocher of the iris was heightened with touches of lemon yellow. The mushrooms were given a final shading with burnt sienna and with a bit of black added to Chinese orange. The gills and stems were more heavily tinted with ocher and burnt sienna to kill the white and make these lesser parts recede into the background. The foreground grass was then shaded with burnt sienna and burnt umber to give it depth. The final touches were pure white highlights for a wet shine, and brilliant tones of viridian green mixed with white.

83

The skulls of six types of prehistoric man drawn in pen-and-ink-line and -stipple for the *Encyclopedia Americana.*

GEOLOGY AND PALEONTOLOGY

The study of rocks and fossils might appear to be as dry as geological dust, but this initial impression is deceptive. One of the first of the sciences children show sustained interest in is paleontology—they love dinosaurs! Growing up they may exhibit strong tendencies toward fossil collecting and as adults might make lengthy trips to see that geological masterpiece, the Grand Canyon. When one stops to consider the numbers of people that stare in fascination at any great gem or mineral collection, it becomes obvious that there is great interest in these aspects of nature.

The artist or illustrator working in these broad fields has, as you can see, many different byways to travel. If your first love is paleontology and you have spent many happy hours wandering through the dinosaur halls of a museum, an opportunity to paint these fabulous creatures of the past may be an inspiring challenge. For models, the fossil remains of prehistoric reptiles and mammals offer excellent starting points.

Fortunately, museum curators arrange their specimens in lifelike poses so that if you want a brontosaurus, the fossils presented in the brontosaurus displays can be the basis for a fine painting or drawing. Of course, the color and texture of the skin of extinct animals is a matter of speculation, and this is where your own best judgment coupled with an imaginative eye comes into play. With any of the saurians your guess concerning what it really looked like is as good as that of anyone else. As long as you refer frequently to the skeletal structure, your chances of creating a convincing, lifelike animal are excel-

lent. Illustrations of dinosaurs or ancient mammals too often have a one-dimensional look about them, almost as though they were total inventions. But as we know they once really existed, it is probably safe to say that if one of these creatures were alive today, it would move pretty much like any animal with a similar underlying structure. Anatomically the relationship of dinosaurs to the reptiles of today is fairly close. In the case of the birdlike dinosaurs, such as those of the genus Ornitholestes, even some of the bone development is parallel with that of bird skeletons of today. There is always something that can be found in the present world of nature to serve as a model that will help breathe life into a drawing of a prehistoric animal.

Wyoming fish fossil
(36 to 58 million years old)

Illustration of the volcanic island Surtsey exploding out of the sea.

The speculative aspects of paleontology—the uncertainty about the true nature of dinosaurs and other archosauria—provide one kind of stimulation for the imagination. Geology—the wonderful shapes and colors of minerals, rocks, and land forms, in all their dazzling variety—can be equally fascinating. It also calls for different techniques. Illustrating geological subjects often requires the use of drafting tools and other mechanical aids, since the work can be quite exacting. Some of it, indeed, is akin to drafting, although this is not the whole story. The occasional textbook or reference book may require comparative drawings of varieties of quartz crystals, or illustrations showing cut and polished gems. Here you may revel in the unique and enjoyable task of rendering subtleties of color and texture. With a splendid specimen on hand, this can be truly pleasant though meticulous work.

Geological illustration also includes the skills used in representing cross sections of landforms. These usually require a special kind of precision. There are standard symbols that are generally used to identify specific types of rock formations. The artist's adherence to these formal symbols makes it possible for the interested viewer to tell at a glance what the cross section represents geologically. In a way, this set of symbols is the "Latin" of the geologist.

These kinds of illustration encompass a great many offshoots. Paleontology and paleobotany are fruitful fields for the professional illustrator. Photographs are of some use in portraying rock formations, but the distinctions among different earth layers are more easily shown in an artist's rendering and much geological explanation centers around subjects hidden within the earth, beyond the reach of photography. In paleontology, the visual representation of prehistoric flora and fauna is a task that belongs entirely to the artist.

The following pages demonstrate some of the many aspects of these fields of nature illustration and the techniques that can be brought into play to make your efforts successful.

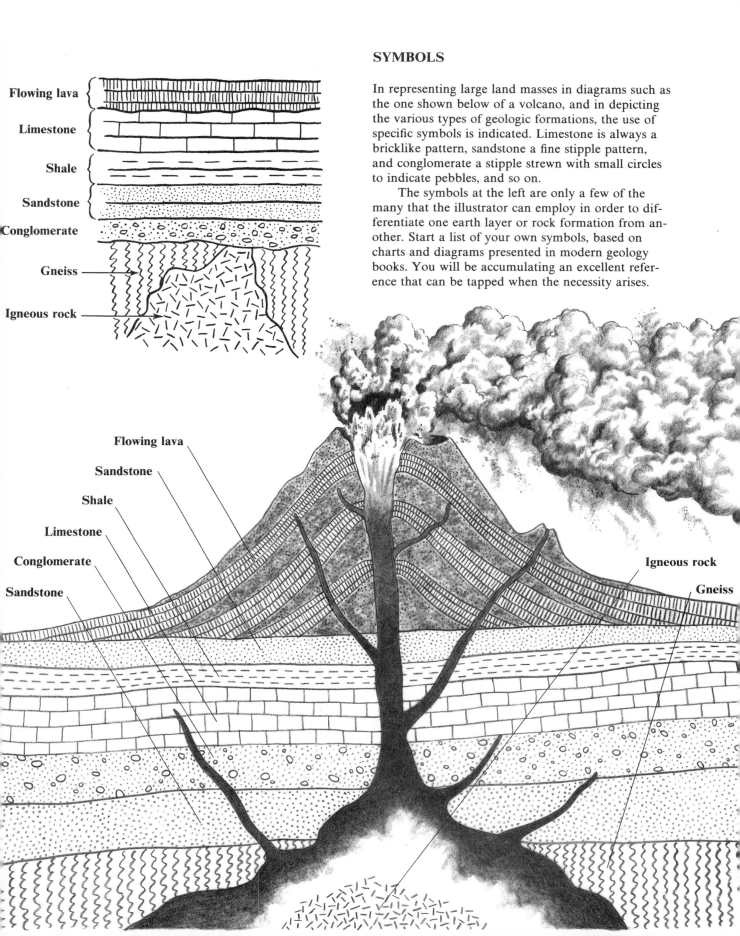

SYMBOLS

Flowing lava

Limestone

Shale

Sandstone

Conglomerate

Gneiss

Igneous rock

In representing large land masses in diagrams such as the one shown below of a volcano, and in depicting the various types of geologic formations, the use of specific symbols is indicated. Limestone is always a bricklike pattern, sandstone a fine stipple pattern, and conglomerate a stipple strewn with small circles to indicate pebbles, and so on.

The symbols at the left are only a few of the many that the illustrator can employ in order to differentiate one earth layer or rock formation from another. Start a list of your own symbols, based on charts and diagrams presented in modern geology books. You will be accumulating an excellent reference that can be tapped when the necessity arises.

Flowing lava

Sandstone

Shale

Limestone

Conglomerate

Sandstone

Igneous rock

Gneiss

TECHNIQUES

Geologists are rarely artists, and not many artists have an extensive knowledge of geology. Most illustrators have to rely almost entirely on the geologists they are working with to give them adequate information that can be translated into explanatory drawings but this process can be expedited and supplemented by having at hand one's own reference sources.

The illustrations shown at the bottom of these pages and in Plates 28 and 29 were done in full color for a filmstrip. The large areas were painted in flat, contrasting colors. When they were dry, they were lightly sprayed with workable fixative, and the straight lines and curves were drawn with the aid of a ruling pen and French curves. The stippling and the shorter lines were painted with a #000 watercolor brush. The map on page 89 was created in a similar fashion. The original sketch for the map began as a mechanically drawn ellipse, but after the sketch was transferred to the illustration board, the painting was rendered without the use of mechanical devices.

The most common type of geology cross-section drawing is based on a block. It is literally a chunk taken out of a landscape, with all the geological structures clearly shown to illustrate appropriate text. A good working knowledge of perspective is an advantage in completing such assignments.

A neat, crisp drawing is the ultimate goal of scientific geology illustration. Although there are parts of drawings that only the steady hand can accomplish, straight edges, perfect corners, and clean ellipses and circles call for mechanical aid. Before starting a geology assignment be sure you are fully equipped with French curves, T-squares, triangles, mechanical drawing and ruling pens, rulers, and compasses.

Flat color, in combination with black line, helps

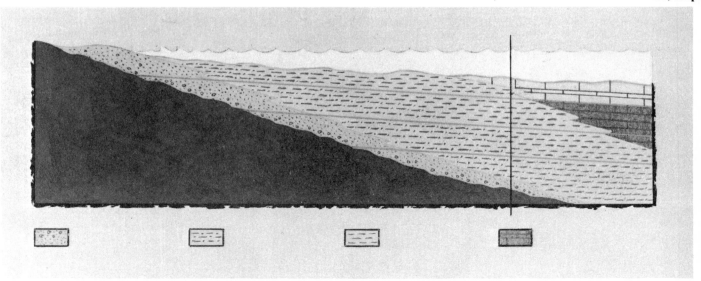

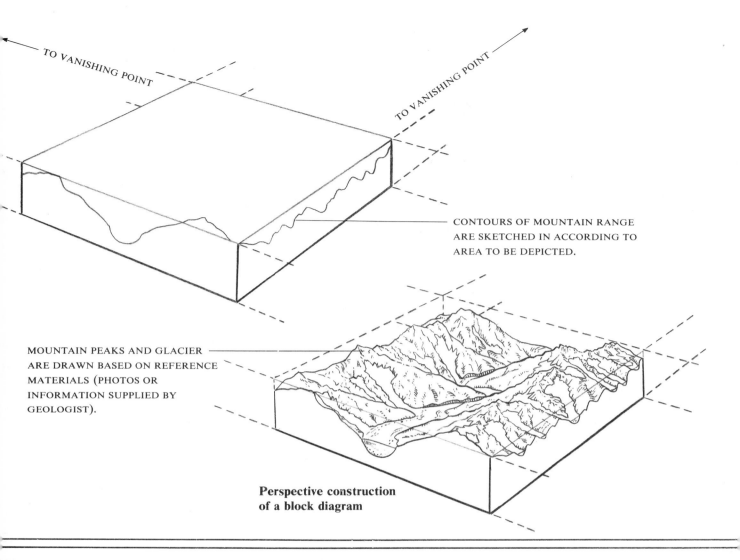

CONTOURS OF MOUNTAIN RANGE
ARE SKETCHED IN ACCORDING TO
AREA TO BE DEPICTED.

MOUNTAIN PEAKS AND GLACIER
ARE DRAWN BASED ON REFERENCE
MATERIALS (PHOTOS OR
INFORMATION SUPPLIED BY
GEOLOGIST).

TO VANISHING POINT

TO VANISHING POINT

**Perspective construction
of a block diagram**

ine geological and geographical divisions.

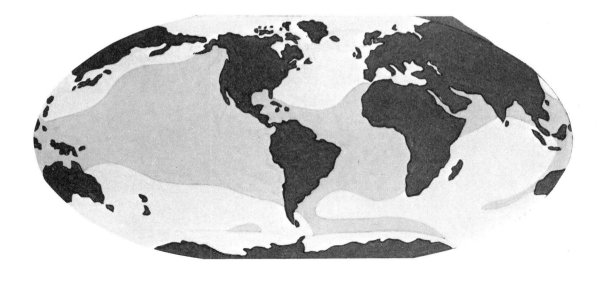

MINERALS AND GEMS

The quartz crystals shown here are transparent and tend to pick up reflections from many angles. The natural shape of each sparkling crystal contributes to the way the light dances from surface to surface.

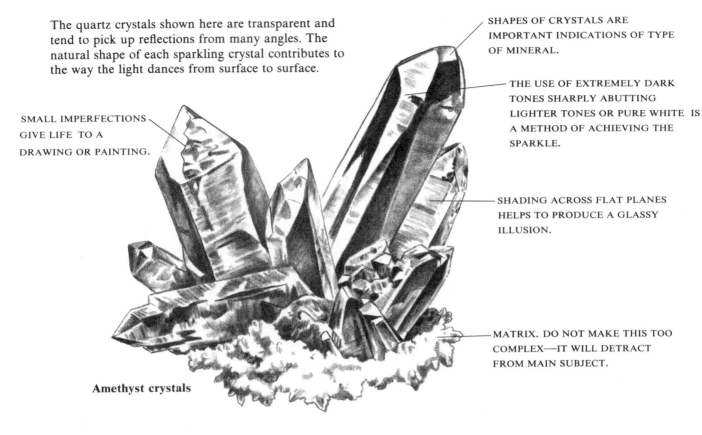

SMALL IMPERFECTIONS GIVE LIFE TO A DRAWING OR PAINTING.

SHAPES OF CRYSTALS ARE IMPORTANT INDICATIONS OF TYPE OF MINERAL.

THE USE OF EXTREMELY DARK TONES SHARPLY ABUTTING LIGHTER TONES OR PURE WHITE IS A METHOD OF ACHIEVING THE SPARKLE.

SHADING ACROSS FLAT PLANES HELPS TO PRODUCE A GLASSY ILLUSION.

MATRIX. DO NOT MAKE THIS TOO COMPLEX—IT WILL DETRACT FROM MAIN SUBJECT.

Amethyst crystals

In the same way that the natural crystal reflects light, so also does the cut gem. Although the cuts on both sides of the gem are symmetrical, the light should not seem to hit all the facets equally. That would be unlikely, mechanical-looking, and uninteresting.

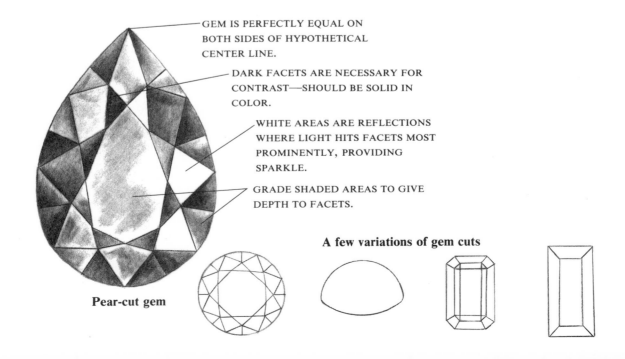

GEM IS PERFECTLY EQUAL ON BOTH SIDES OF HYPOTHETICAL CENTER LINE.

DARK FACETS ARE NECESSARY FOR CONTRAST—SHOULD BE SOLID IN COLOR.

WHITE AREAS ARE REFLECTIONS WHERE LIGHT HITS FACETS MOST PROMINENTLY, PROVIDING SPARKLE.

GRADE SHADED AREAS TO GIVE DEPTH TO FACETS.

A few variations of gem cuts

Pear-cut gem

ROCKS

ROCK IS TEXTURED TO INDICATE ITS COMPONENTS—MICA AND HORNBLENDE ARE THE DARK PARTS, FELDSPAR AND QUARTZ ARE LIGHT.

VARY SHAPES AND SIZES OF FLECKS TO FOLLOW SPECIMEN.

KEEP SHADOWS LIGHT—HEAVY ONES OBSCURE TEXTURE.

USE ONE LIGHT SOURCE.

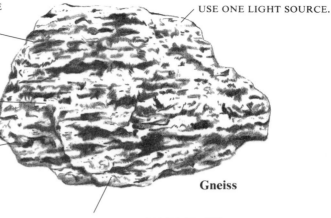

Gneiss

OBSERVE CHARACTERISTIC SHAPES OF ROCKS.

Instead of the sparkling crystalline qualities of quartz and other gemstones, rocks have a heavy solidity in appearance. Texturally they have great variations, minute surface differences by which they are identified and classified.

Specimens can be obtained inexpensively from rock shops that cater to the "rock hound." Shop owners are more than willing to help the customer make a good selection. Working from specimens, it is relatively easy for the artist to mimic the colors and textures of the rock in front of him, using lighter and darker shades to indicate depressions, fissures, bulges, and striated layers.

DARK SHADOWS EMPHASIZE SURFACE LAYERING.

UPPER SURFACE IS SMOOTHLY SHADED.

Shale

NOTE LAYERED EFFECT COMMON TO SHALE AND ACCOMPLISHED BY SHADING UNDER LIGHTER AREAS TO ACCENT BREAKS IN CONTINUITY OF ROCK.

PEBBLES IN CONGLOMERATE SHOULD BE LIT BY ONE LIGHT SOURCE.

SMOOTH SHADING HERE IS IN CONTRAST TO THE ROUGHER NATURE OF THE REST OF THE ROCK.

SHADOWING OF SMALLER GRAINS IS SIMILAR TO LARGE ONES— SUCH DETAILS GIVE THE DRAWING NECESSARY CHARACTER.

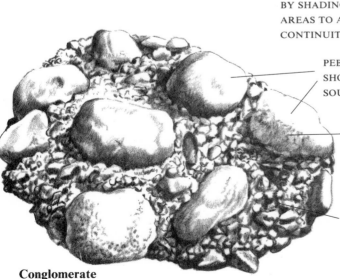

Conglomerate

PREHISTORIC ANIMALS

Ornithomimus, one of a genus of
ostrichlike dinosaurs

Dinichthys, one of a genus
of prehistoric fishlike creatures

Fossil of an *Ichthyosaurus,* a
genus of prehistoric aquatic
reptiles

One aspect of illustrating historical geology seems almost paradoxical. Although the limits of the subject can be particularly rigid, dictated by the specific scientific guidelines presented by fossil evidence, no one can do more than conjecture what the animals or their landscapes actually looked like. The artist can therefore let his imagination roam, calling upon the available facts and weaving into them his own imaginative concepts.

However, when preparing to paint or draw a prehistoric scene, we must remember that as millions of years passed, enormous changes took place and both animals and vegetation evolved in new forms. To mix vegetation of one era with animals of another, or to have some prehistoric beasts living out of their historical context in the same scene with animals of another time, is as unsatisfactory as placing a camel in a jungle.

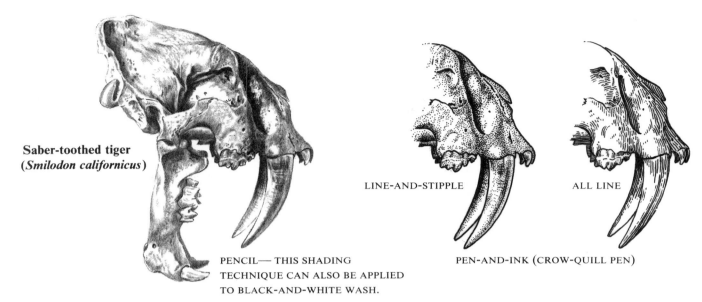

Saber-toothed tiger
(*Smilodon californicus*)

LINE-AND-STIPPLE

ALL LINE

PENCIL— THIS SHADING
TECHNIQUE CAN ALSO BE APPLIED
TO BLACK-AND-WHITE WASH.

PEN-AND-INK (CROW-QUILL PEN)

TECHNIQUES

Pencil, pen-and-ink-line, and pen-and-ink-stipple are three popular mediums for rendering fossil and bone drawings, but there are also ways of illustrating such subjects in full color.

Real specimens to work from are rarely available, but photographs, sketches of museum specimens, or replicas purchased from scientific supply houses may serve instead. Replicas can be expensive, even if you are lucky enough to find what you are after, but are often worth considering.

A proportional divider is helpful for doing the original sketch. Bone and fossil drawings used to illustrate a serious text need to be totally accurate. A drawing that does not depict all important detail cor-

rectly placed defeats the purpose of the illustration. The drawing of various members of the genus *Brontotherium* shown here is an example of how the evolution of prehistoric mammals can be illustrated. Despite the many differences between ancient animals and those living today, it is comforting to know that in most cases there are modern parallels for extinct species.

If you are asked to draw a creature of the genus *Brontotherium* and have little beyond a museum skeleton to use as a guide, the rhinoceros with its bulk, manner of movement, and skin texture, will serve as a model on which you can base the surface details that will make your drawing seem more real and alive.

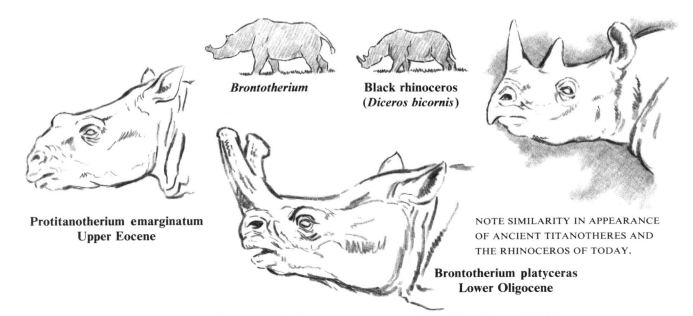

Brontotherium

Black rhinoceros
(*Diceros bicornis*)

Protitanotherium emarginatum
Upper Eocene

NOTE SIMILARITY IN APPEARANCE
OF ANCIENT TITANOTHERES AND
THE RHINOCEROS OF TODAY.

Brontotherium platyceras
Lower Oligocene

DEMONSTRATION: HEAD OF TYRANNOSAURUS REX

Excavated from a rocky tomb and reconstructed in a lifelike posture, the skeleton of Tyrannosaurus rex evokes only a shadow of its ancient terror. But the artist views the remains of this reptilian predator in a more imaginative way, sees the skeleton clothed in muscle, sinew, and skin, moving on powerful hind legs and lashing its tail angrily in the dry dust of a prehistoric plain. In his mind's eye, the creature's teeth gleam again in a half-opened mouth and cold, hooded eyes watch hungrily for any movement in the browned grass. That feeling of life is the essence of this kind of illustration; it is the step that goes beyond mere observation.

Although the skull of this prehistoric beast is not like that of any existing species, it has similar basic features: the nasal orifices, the eye sockets, and the heavily toothed jaw are almost but not quite crocodilian. It is therefore fair to assume that many of the Tyrannosaurus rex's surface features would be closely akin to those of the reptiles of today even though the bone structure is different.

The illustration on the opposite page is a synthesis of many things. In preliminary research among photos of living reptiles for models with a reasonable resemblance, we found that the heads of certain iguanas and other lizards offered possibilities for development. The scale would have to be exaggerated to a great degree, and for the rest, educated guesses, along with what could be deduced from the skull shape, were all we had to rely on in preparing the finished sketch.

A drawing of the fossil skull was done first. This was placed under the sheet of heavy tracing paper on which the final sketch was to be created. The ocular ridge, vertically slitted eye, and wrinkled, warty neck were drawn over the skull, with the rest of the head following the general contours of the fossil.

When the drawing was completed, it was transferred to an 11″ × 14″ canvas board that was chosen for the interesting texture it would impart to the finished painting. Casein color, rather than oil paint, was decided upon because its quick-drying qualities promote spontaneity in execution and effect. A water-soluble medium, it was handled here in much the same way as gouache.

The first color, a mixture of yellow ocher and Naples yellow, was washed in with a large watercolor brush over the entire head, leaving only the teeth white. The next step was to mix a lighter tone by adding a small quantity of white to the original color, thus thickening it as well. This new tone was painted over the basic wash along the high points indicated by the bone structure of the skull. To give these high points a three-dimensional look, darker accents were added with a mixture of burnt sienna and burnt umber. The warts, neck wrinkles, and scalelike areas around the mouth were highlighted with a still lighter shade of yellow ocher and shaded carefully with the burnt sienna and burnt umber mix. A light cobalt-blue wash was painted over the neck area when it was dry, and Shiva violet, lightened with white, was used for additional touches that lent a more lively

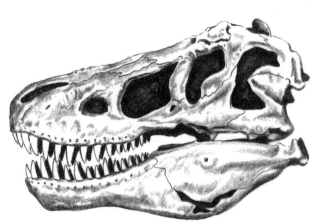

Fossil of skull of Tyrannosaurus rex

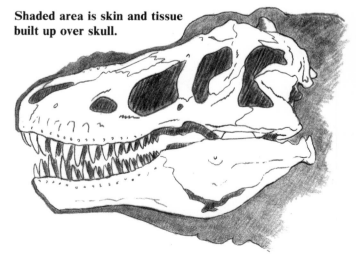

Shaded area is skin and tissue built up over skull.

look to the otherwise monochromatic color scheme.

With a #0 watercolor brush, the black of the vertical pupil of the eye was painted over the base color of cadmium yellow light that was used for the iris. Over this a tint of cobalt blue was applied, leaving a thin yellow line around the pupil. A very white highlight added life, and a small dot was placed in the lower corner of the eye for a final realistic touch. The surrounding wrinkles were modeled with a mixture of burnt sienna and burnt umber. A light touch of pale yellow ocher on the upper eyelid makes it stand away from the eye.

Finally, Payne's gray, mixed with a bit of yellow ocher, and white were used to shade in the teeth; these were further shadowed with a combination of Payne's gray and black. The tissue at the back of the mouth was painted with a mixture of cadmium red extra-light and white, with pure white adding the lifelike effect of a wet shine. The brushstroked background behind the head was done with a blend of white and chromium-oxide green deep.

As casein color appears somewhat chalky when dry, the finished art was sprayed with Myston to brighten it.

95

Swamp flowers. See also Plate 16.

BOTANY

On a planet covered with green and growing plants, the role of the botanical artist is obvious. Through the centuries the artist-botanist has recorded living plants, using every conceivable technique and method. Plants have been employed in designs dating from our earliest history; they figure in works of art ranging from the mosaics of Herod's palace floors, to the magnificent tapestries of medieval Europe, to the beautifully worked silver services and colorful textiles we use today.

The wealth of material in the plant kingdom is never ending. The beauty of the tiniest sepal on the underside of the most obscure flower warrants careful, loving observation, for therein lies the true essence of design, the most perfect of nature's works, and the closer you approach this marvel, the more complex and awe-inspiring it becomes.

For the artist interested in this phase of nature illustration, the easy availability of plant material is a great advantage. Aside from the winter months (in our northern areas) when outdoor plants are limited, practice specimens are merely a tree away, out in the garden, or down the block in a park or vacant lot. Any plant you might choose would make an excellent drawing or painting; even a simple blade of grass can have a grace all its own.

Albrecht Dürer's painting "Das Grosse Rasenstück," done in 1503, has endured even though the subject matter does not at first glance seem to have much to offer. It is at the second glance that one recognizes the full content of this lively piece of turf and acquires a sense of how it was captured forever by this skillful artist.

There are many kinds of botanical illustration. First, there is the meticulous, scientifically oriented botanical painting, employed many times as an adjunct to a botanist's text or as an individual specimen plate to illustrate a new species. Then there are the drawings and paintings that are used in horticultural magazines and other publications. Along with these varieties of botanical art there are the plant drawings utilized in children's books and as background material for illustrations of animals or insects. These kinds of illustration should in no way be less accurate than the more scientific ones, but the techniques and rendering should perhaps be a little less formal, to give the subject a lighter look. There is no reason to dispense with the usual aim of accurate representation, even though you may think that the project you are working on does not require it. The more you learn about the structure of plants, the more unlikely it is that you will believe that a loosely scribbled edge on a leaf is the answer to the problem at hand. Your technique can be free and yet be realistically authentic. The idea, of course, is to know your plants well enough to appreciate what you can justifiably leave out and so enjoy such freedom while remaining faithful to your artistic aims.

Death-cup mushroom
(*Amanita phalloides*)

The techniques for rendering botanical subjects vary with the intended use of the illustration. Almost any medium is appropriate—pen and ink, scratchboard, gouache, watercolor, and even woodcuts can be vehicles for your artistic expression.

The collection of plant specimens, flowering or nonflowering, can be accomplished without difficulty, and your collection can be the basis for most of your plant drawings. A useful way to supplement this collection is to also use photographs. Photographing each plant before it goes into the press should give you a record of its color and the general effect of the way it appears in life. It is wise to put aside a large stock collection that you can draw upon in the winter or at times when particular plants are no longer at the peak of their season.

Best of all, though, is working directly from the live specimen, and in this regard the city dweller is just as well off as his suburban counterpart. Plants from the local florist, either potted varieties or individual cut flowers, will be quite adequate, providing subject matter for many hours of rewarding work.

Never let it be said that any form of botanical art is easy. It is just as important to maintain authenticity of detail and proportion here as in any other type of nature illustration. But for those who love plants of all kinds, and delight in the color and the texture of a petal or the way a leaf grows out of the stem, it can be a worthwhile vocation, one full of new and fascinating discoveries.

Broadleaf trees make up a good part of the plant life in temperate landscapes. They also grow alongside palms and conifers in other climates. The typical shapes of trees such as maples and oaks vary according to species, but additional deviations in outline occur naturally as a result of wind breakage and crowding. The artist should keep in mind basic species characteristics even when his portrayal is to be impressionistic rather than scientific. See Plate 18.

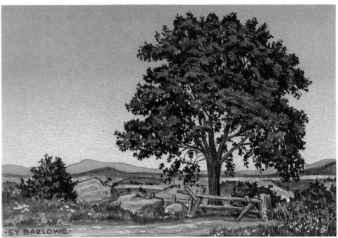

Palms are decorative trees, with graceful outlines and exotic leaf shapes. They immediately suggest to the viewer that the scene is a tropical one. The artist should make a special effort to capture the true grace inherent in these trees, because even when they are only background material, portraying them in a spiky, unnatural-looking fashion can ruin otherwise interesting work.

Conifers illustrated in proper settings can be dramatic whether shown as trees or in tier upon tier on a mountainside. Evergreens of the same species vary according to growing conditions—for example, forest-grown trees have longer trunks that branch out at a higher level than field-grown trees. Be sure that the conifer (or any other tree) you are using is native to the area portrayed in your landscape.

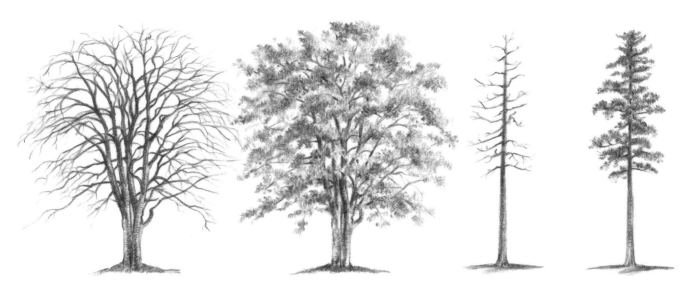

ANATOMY OF TREES

The bare branches of a tree in winter reveal the anatomy that lies beneath a summer's growth of leaves.

Evergreens do not drop their needles seasonally, but the general conformation of the branches can readily be seen at all times of the year.

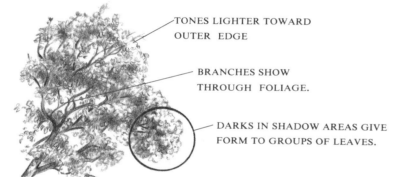

TONES LIGHTER TOWARD OUTER EDGE

BRANCHES SHOW THROUGH FOLIAGE.

DARKS IN SHADOW AREAS GIVE FORM TO GROUPS OF LEAVES.

Broadleaf or deciduous trees

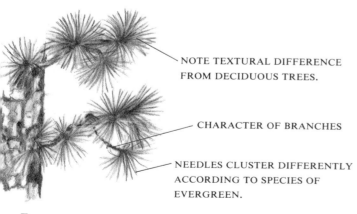

NOTE TEXTURAL DIFFERENCE FROM DECIDUOUS TREES.

CHARACTER OF BRANCHES

NEEDLES CLUSTER DIFFERENTLY ACCORDING TO SPECIES OF EVERGREEN.

Evergreens

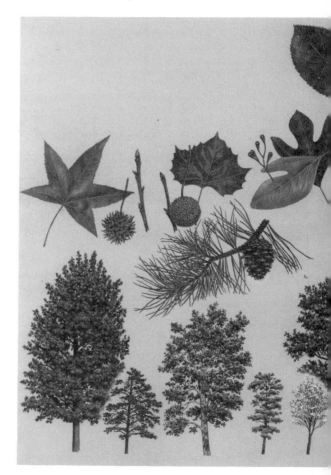

100

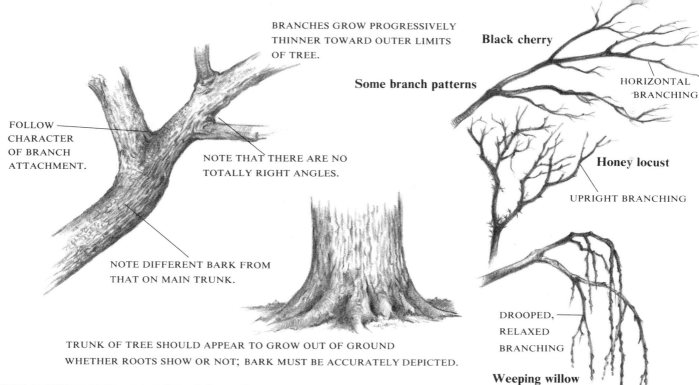

BRANCHES GROW PROGRESSIVELY THINNER TOWARD OUTER LIMITS OF TREE.

Black cherry

Some branch patterns

HORIZONTAL BRANCHING

FOLLOW CHARACTER OF BRANCH ATTACHMENT.

NOTE THAT THERE ARE NO TOTALLY RIGHT ANGLES.

Honey locust

UPRIGHT BRANCHING

NOTE DIFFERENT BARK FROM THAT ON MAIN TRUNK.

DROOPED, RELAXED BRANCHING

TRUNK OF TREE SHOULD APPEAR TO GROW OUT OF GROUND WHETHER ROOTS SHOW OR NOT; BARK MUST BE ACCURATELY DEPICTED.

Weeping willow

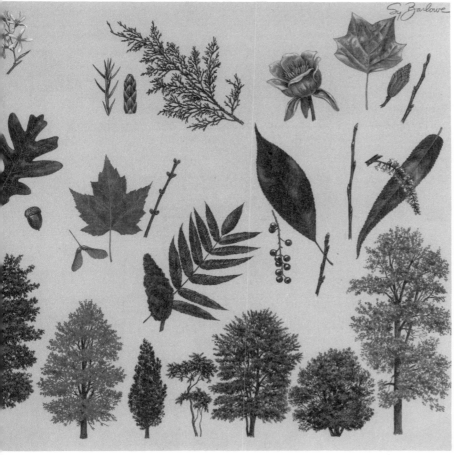

The leaves may vary slightly within the species and even on the same tree, depending on growing conditions. These variations become increasingly obvious as you work directly from nature. Take note of the smaller details, such as the venation of the leaves and the way in which flowers, fruit, and leaves are attached to the twigs. Observe how twig meets branch and branch meets trunk. Finally, since all trees have bark that distinguishes one species from another, practice drawing several different varieties in order to acquaint yourself with this important aspect of their appearance.

As the painting shown at left and in Plate 20 indicates, the general shape of the tree is not the only source of interest. Each species displays a varied wealth of detail. For example, all trees bear flowers; some are barely visible, while others, such as those of the tulip tree, are colorful and showy.

COLLECTING PLANTS

A serious problem for the botanical illustrator is an assignment that arrives in the winter, when most plants are dormant. To prepare for this eventuality, he should, squirrel-like, gather a collection for the winter during the summer months, using a plant press and a camera. A plant press may be purchased from any reputable scientific supply house or it can be simply constructed from two pieces of half-inch-thick plywood placed on either side of a stack of sheets of corrugated cardboard and blotting paper, all bound with a heavy woven bookstrap, as shown above. The press itself is usually about twelve by sixteen inches, and the sheets of blotting paper and cardboard about twelve by twenty inches.

After collecting the plants you wish to press, place one specimen at a time between two pieces of blotting paper that are sandwiched between two pieces of corrugated board. Repeat this procedure until you have as large a pile as seems practical, then place the pressed material between the plywood covers, and bind it all securely with the bookstrap.

Left to dry for two or three weeks, the pressed plants are then gently removed from the press and spread with care on heavy white paper. Small strips of tape are used to hold the plant in place. When all is complete, each herbarium specimen you now have should be labeled carefully as to locale, date collected, colloquial and scientific name, and your name as the collector. Slipping the specimen between a single fold of newspaper helps to protect it when it's not being used. Polaroid pictures or 35mm slides taken before the plants are pressed would be valuable adjuncts to the herbarium specimens, to refresh your memory of the appearance of the living plants. If no camera is available, a file of pictures from nature magazines and garden catalogs will provide a store of visual references that you can call upon when necessary.

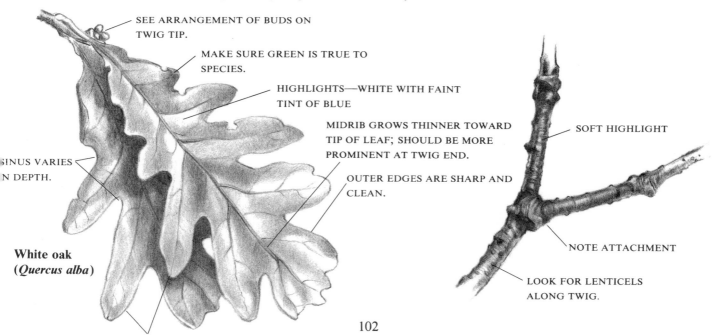

SEE ARRANGEMENT OF BUDS ON TWIG TIP.

MAKE SURE GREEN IS TRUE TO SPECIES.

HIGHLIGHTS—WHITE WITH FAINT TINT OF BLUE

MIDRIB GROWS THINNER TOWARD TIP OF LEAF; SHOULD BE MORE PROMINENT AT TWIG END.

SINUS VARIES N DEPTH.

OUTER EDGES ARE SHARP AND CLEAN.

White oak
(*Quercus alba*)

SOFT HIGHLIGHT

NOTE ATTACHMENT

LOOK FOR LENTICELS ALONG TWIG.

LOBE MAY VARY BUT WILL REMAIN TRUE TO SPECIES.

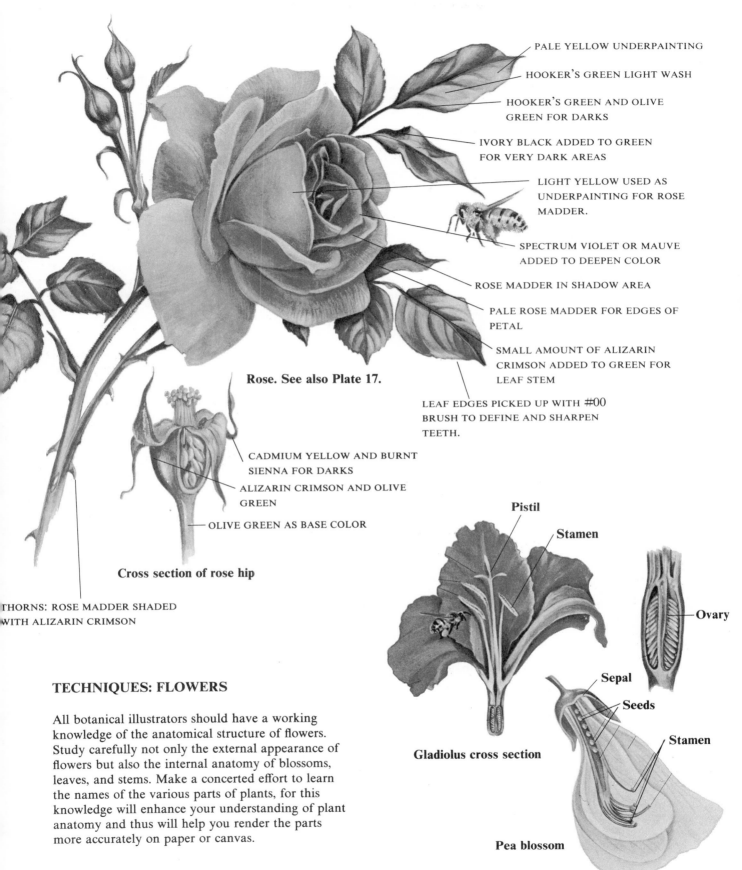

PALE YELLOW UNDERPAINTING

HOOKER'S GREEN LIGHT WASH

HOOKER'S GREEN AND OLIVE
GREEN FOR DARKS

IVORY BLACK ADDED TO GREEN
FOR VERY DARK AREAS

LIGHT YELLOW USED AS
UNDERPAINTING FOR ROSE
MADDER.

SPECTRUM VIOLET OR MAUVE
ADDED TO DEEPEN COLOR

ROSE MADDER IN SHADOW AREA

PALE ROSE MADDER FOR EDGES OF
PETAL

SMALL AMOUNT OF ALIZARIN
CRIMSON ADDED TO GREEN FOR
LEAF STEM

LEAF EDGES PICKED UP WITH #00
BRUSH TO DEFINE AND SHARPEN
TEETH.

Rose. See also Plate 17.

CADMIUM YELLOW AND BURNT
SIENNA FOR DARKS

ALIZARIN CRIMSON AND OLIVE
GREEN

OLIVE GREEN AS BASE COLOR

Cross section of rose hip

THORNS: ROSE MADDER SHADED
WITH ALIZARIN CRIMSON

Pistil

Stamen

Ovary

Sepal

Seeds

Stamen

Gladiolus cross section

Pea blossom

TECHNIQUES: FLOWERS

All botanical illustrators should have a working knowledge of the anatomical structure of flowers. Study carefully not only the external appearance of flowers but also the internal anatomy of blossoms, leaves, and stems. Make a concerted effort to learn the names of the various parts of plants, for this knowledge will enhance your understanding of plant anatomy and thus will help you render the parts more accurately on paper or canvas.

103

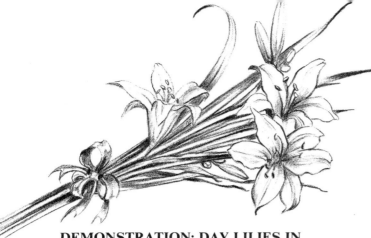

DEMONSTRATION: DAY LILIES IN GOUACHE

This painting started with a bouquet of garden flowers and leaves. The day lily is a good subject because its basic form is uncomplicated. The individual lilies

each lasted only one day, but our garden fortunately provided a daily replacement until the painting was completed.

A realization that lilies in the vase would fade the next day prompted a sketch that was completed in a single sitting. The lilies were kept in water close by the drawing board, for easy observation and arrangement. The darker one at the lower left nicely balanced the flamboyance of the two lighter ones and the bud. Moving the flexed leaves over to the left also added to the balance of the composition. Had the leaves been upright, there would have been too little weight in the stem area.

The detailed sketch was then carefully traced onto a piece of double thick Bainbridge #80 illustration board. Its kid finish readily accepts watercolor or gouache. The first washes of gouache were then ap-

plied with a #2 Winsor & Newton watercolor brush. Brushes used varied from a #2 down to a #000 (triple 0).

The palette for this painting (shown in color in Plate 22) consisted of lemon yellow, cadmium yellow deep, cadmium yellow medium, alizarin crimson, burnt sienna, raw sienna, Hooker's green and Hooker's green deep, plus black and white.

Initially the color was washed into all areas, making the final effect more easily apparent. Lemon yellow was the base for the lighter flowers, and the cadmiums for the darker one. When working with any shade of yellow, the artist has to decide early on what color is appropriate for shading because a poor selection will produce a muddy appearance. Raw sienna and small amounts of Hooker's green were chosen as the best compromise for shading all the yellows.

As the work progressed, the plants were given closer scrutiny, edges were ruffled, and venation was attended to with soft outward strokes of shading. The highlights were accomplished with the addition of small quantities of white to the base color of the flowers. Deep alizarin crimson mixed with a minute amount of burnt sienna was feathered in with short strokes on the patterned area of the darker lily, and the anthers were lightened considerably with paler yellows and shadowed to make them stand forward in the composition. The leaves, which were left for last, were veined in some places in order to give them more solidity, but they were left free in others so as not to lose the effect of spontaneity, and were then finally faded off to the white of the board. A touch of burnt sienna was added along the stems where the faded flowers had once been, and, lastly, the stems themselves were more crisply defined with sharp outlines and pure white highlights.

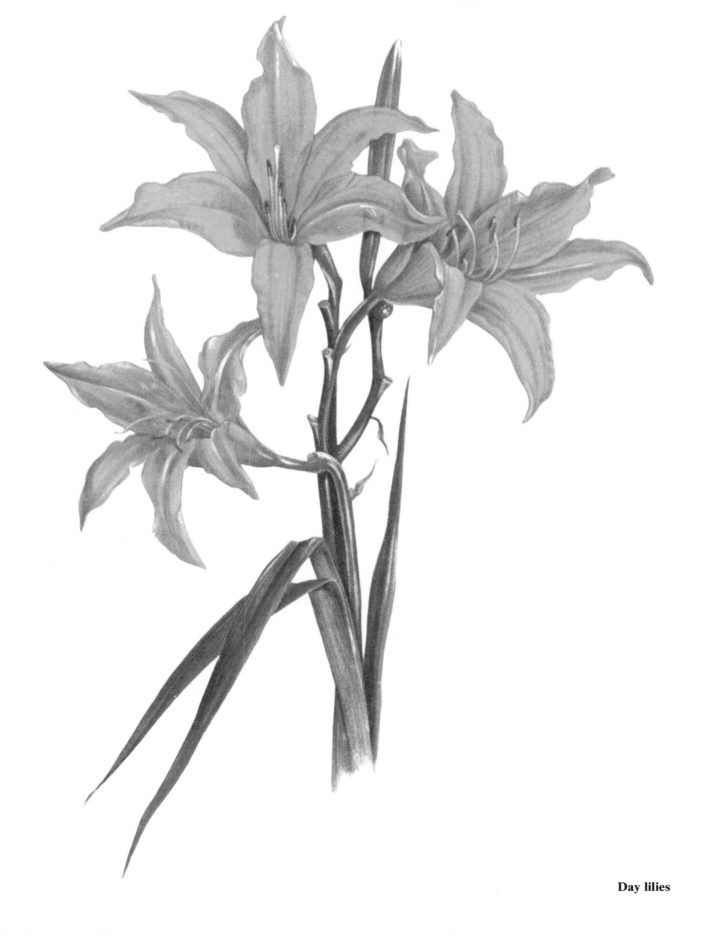

Day lilies

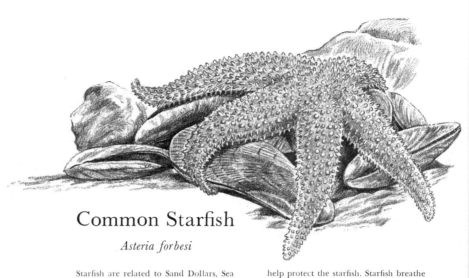

Common Starfish

Asteria forbesi

Starfish are related to Sand Dollars, Sea Urchins, Sea Cucumbers, and Sea Lilies.

There are about one thousand different kinds of starfish. The Common Starfish, which is found along the eastern coast of North America, has five arms. Other kinds of starfish have more arms.

The mouth of the starfish is in the center of the undersurface. From here the five arms stretch out in each direction. The starfish has a skeleton. This consists of little plates that lie right underneath the skin. On many of them are spikes that help protect the starfish. Starfish breathe through small pouches that stick out between the spikes. They are called skin gills. Around each skin gill is a ring of little pincers called *pedicellaria*. They keep dirt and small animals away from the skin gills. On the underside starfish have hundreds of little tubes, which are filled with water. With the help of small muscles the starfish can stretch each tube out and pull it back in. At the tip of each tube foot there is a little suction cup with which the starfish can hold onto things very tightly. Each tube foot is not very strong by itself, but when many work together, they can be very strong. The starfish uses its tube feet for crawling slowly over the rocky bottom of the shallow sea in which it lives. At the tip of each arm is a small light-sensitive spot that works like an eye. Inside each arm are parts of both the stomach and the sex glands.

When the starfish comes across a mussel or oyster, it will attack it. The mussel or oyster will close its valves with its

Food: oysters, clams, mussels

16

THE ILLUSTRATOR'S CAREER

YOU AND THE PUBLISHER

There is something about a publisher's assignment to illustrate a book or article on nature that is both exhilarating and burdensome. When the page-by-page lists for a book are in your hands and the monumental research task confronts you, you realize with startling finality the responsibility that has been cast your way. By this time you have probably met with the author and reached a sufficient understanding about details so that the two of you will be working on parallel paths. The Book is uppermost in your minds, but it is still an imaginary product, its realization dimly envisioned as occurring sometime in the future but growing ever clearer as you begin mentally to lay out the pages. The real work begins when you approach the drawing table, with pencils sharpened and ruler in hand, and meet eye to eye with a very blank piece of tracing paper.

There are many publishers whose editorial staffs not only determine beforehand the format of a book (its size, number of pages, and location of illustrations), but will actually approach the artist with a fully conceived and laid-out book. This of course is a kind of Nirvana, an ideal situation in which the artist is saved many hours, perhaps many months, of time and work. But be that as it may, some artists prefer the freedom and potential of receiving only the prepared text, the type size, and the author's and publisher's faith in his overall ability.

Even though nature illustration has so many uses in nature books, children's books, scientific studies, textbooks, and magazines, it is sometimes difficult to answer the two inevitable questions that serious students ponder: Is there much work in this area, and does it pay well? Let it suffice to say that in a field such as this, the quality of

Opposite: A page from a children's book about nature. The illustrations were drawn in pencil. Proofs of the type were pasted in place on an overlay of tracing paper, precisely positioned for the printer.

one's work can open a highly competitive and apparently closed market to "just one more" artist. And in ordinary times, sufficient versatility, skill, and dedication should provide him with an adequate reward.

The professional nature illustrator should take most things in stride, and he should be willing to make minor and sometimes even major changes to fit the needs of the author or publisher. He should use his sketches not just as a rough indication of what the final art will look like but as the first step toward his finished work. He should deviate very little from the approved sketch. When completed, the illustration should be camera-ready and clearly labeled as to page and content, because before it appears in print it will pass through many hands.

In the overview, all three—illustrator, author, and publisher—are after the same thing: a book of fine and lasting quality, one that will give the reading public years of pleasure and use, and all those involved in its creation a glow of pride when the book is seen on bookshelves, in stores, and in libraries.

THE PORTFOLIO

For the nature illustrator, building a portfolio of professional quality is a very important goal. Ultimately it will be a valuable asset. It should be a collection of the illustrator's finest work, a means of directly communicating to art directors or art buyers his ability as an artist so that recognition of his talent can be immediate.

At the point when the illustrator has accumulated enough work to consider composing a portfolio, he must begin to make critical choices. Since an aspiring artist cannot expect an art director to sift through a lengthy retrospective of all his work, he must carefully decide which pieces of art are appropriate to the overall image he wishes to project and which are not.

Staying power in the field of nature illustration is ensured by an ability to second-guess the going market, and the key to achieving that aim is versatility. This in no way means that the artist is required to hop from one nature subject to another—we all shine more in one particular aspect of illustration than in another—but he must be able to handle more than "just plants" or "just birds" when first starting out.

To compete with the already established specialists you will need at least as good a portfolio as your competitors are able to show. A well-rounded portfolio of ten or twelve pieces of nature art in as many techniques as you are capable of producing in a professional manner is the prime aim. If along with the nature subjects you feel that you have some especially good artwork outside the nature field, these can be valid additions, but keep these pieces to a minimum in your portfolio. Art editors in textbook houses often find the need to include human figures or inanimate objects in nature illustrations.

There should be a certain uniformity of size in your presentation. Logically establish a range of a few sizes, with pieces of similar dimensions matted in matching-size mats. If you find that after several interviews the mats have become dog-eared, replace them as soon as possible. The whole idea is to show the pride and respect for your work that you hope to inspire in others.

To protect the artwork when it is being handled, many people cut pieces of clear acetate to the appropriate size and slip them under the mat and over the paintings or drawings. This adds an attractive touch as well. If you cannot cut your own mats, a framer or reputable art-supply store will do it for you, for a reasonable fee.

Another way to handle the matter, perhaps not as formal but certainly as efficient, is to "flap" all artwork. This method will work if all the artwork is on illustration board. A sheet of heavy paper is cut to the exact size of your work plus about two extra inches across the top. These two inches are folded over the back of the artwork and glued in place with rubber cement. A piece of acetate is then cut to the outer dimensions of the board, minus about one-half inch across the top. This is taped directly on the front of the work with white masking tape so that it is between the flap and the board and serves to further protect the art. Any substantial paper will protect the work, but we prefer to flap ours with a heavyweight textured paper that is usually used for pastel drawing because it makes a more attractive, professional-looking presentation.

PARTING THOUGHTS

Throughout this book we have walked a fine line between art and science. That, as illustrators, is the path we chose to follow. To advocate that all artists interested in natural-science illustration do the same would be presumptuous. Tastes and goals differ with the individual. The depth and breadth of the subject allows for many interpretations in both technique and medium.

In developing a technique of one's own, the study of the work of other illustrators working in the same field is always helpful, not with the idea of slavishly copying what others have done but with the intention of gaining as broad an understanding as possible of the different ways problems can be handled. Some examples you might find interesting are: *The Animal Art of Bob Kuhn: A Lifetime of Drawing and Painting*, illustrated by Bob Kuhn (North Light Publishers, 1973); *Birds of the World*, text by Oliver L. Austin, Jr., illustrations by Arthur Singer (Golden Press, 1961); *Birds of Town and Village*, text by W. D. Campbell, illustrations by Basil Ede (Country Life Books, 1965); *Insects of the World*, written and illustrated by Walter Linsenmaier (McGraw-Hill Book Company, 1972); *Fishes of the World*, text by Edward Migdalski and George S. Fichter, illustrations by Norman Weaver (Alfred A. Knopf, Inc., 1976); *Prehistoric Sea Monsters*, text by J. Augusta, illustrations by Zdenek Burian (Paul Hamlyn, 1964); *The Complete Book of Fruits and Vegetables*, text by Francesco Bianchini and Francesco Corbetta, translation by Italia and Alberto Mancinella, illustrations by Marilena Pistoia (Crown Publishers, Inc., 1976); and *Plants and Christmas*, text by Hal Borland, illustrations by Anne Ophelia Dowden (Golden Press, 1969).

During our own careers, we have illustrated over thirty nature books and contributed illustrations to many others, which range from scientific works and encyclopedias to children's books. Some of these are listed in the acknowledgments on page 110. These assignments have given us the opportunity to work with many different art techniques—as demonstrated in the pages of this book—and to enjoy earning a livelihood doing what we like most to do. Nature is the prime subject area that we have dealt with in our careers as illustrators, and it is one that has given us great satisfaction. We hope your own experience will be as pleasurable.

Mirorictus taningi, a new genus of deep-sea fish, in an example of scientific illustration done for *Novitates,* a publication of the American Museum of Natural History.

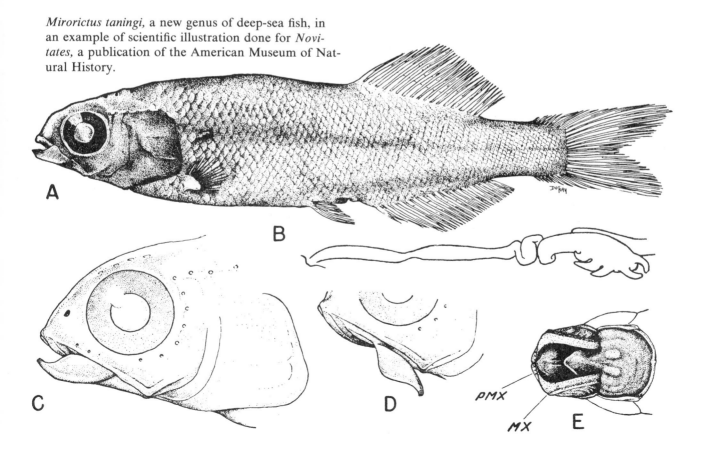

Acknowledgments

The authors are grateful to the following for permission to reproduce some of their earlier illustrations in this book:

American Museum of Natural History: An illustration by Sy Barlowe from *Novitiates,* July 17, 1947, issue no. 1350. (Page 109)

Chanticleer Press, Inc.: Adaptations of illustrations by Sy and Dorothea Barlowe from *The Audubon Society Field Guide to North American Reptiles and Amphibians.* Copyright © 1979 by Chanticleer Press, Inc., under the International Copyright Convention (Berne). (Page 79)

The Cousteau Group, Inc.: Two illustrations by Dorothea Barlowe from *The Art of Motion,* "The Ocean World of Jacques Cousteau" series, volume 5. Published by Harry N. Abrams, Inc. Copyright © 1973 by Jacques-Yves Cousteau. (Pages 48–49; color plates 6 and 9)

Follett Publishing Company: An illustration adapted from *Oceans* by Sy Barlowe. Copyright © 1969 by Follett Publishing Company. (Pages 86 and 92 bottom)

Grolier, Inc.: Illustration by Dorothea Barlowe from *Encyclopedia Americana.* All rights reserved. (Page 84)

Harper & Row, Publishers, Inc., and André Deutsch Ltd.: Five illustrations from *Through the Fish's Eye* by Mark Sosin and John Clark, drawings by Dorothea Barlowe. Copyright © 1973 by Mark Sosin and John Clark. (Pages 51, 52 top left, and 54 bottom)

Hendrickson Publishing Company: An illustration from *A Guide to Long Island Fishing* by Sy Barlowe. Copyright © 1979 by Hendrickson Publishing Company, Inc. (Page 49 top right)

Holt, Rinehart and Winston Publishers: From *The Outermost House* by Henry Beston. Copyright 1928, 1949, © 1956 by Henry Beston. Copyright © 1977 by Elizabeth C. Beston. (Epigraph, page 2)

Los Angeles County Museum of History and Science: Adaptations of illustrations from "Rancho La Brea" by Chester Stock, sixth edition, Science Series 20, 1972. Courtesy of Natural History Museum of Los Angeles County. (Page 93 top)

Macmillan Educational Company, A Division of Macmillan Publishing Co., Inc.: Illustrations by Dorothea and Sy Barlowe from *Merit Students Encyclopedia,* © 1967 by Crowell-Collier Educational Corporation. (Pages 96 and 99 right; color plates 16, 18, and 19)

McGraw-Hill Book Company: Illustrations by Dorothea and Sy Barlowe from *Animals: The Strange and Exciting Stories of Their Lives* by Bertel Bruun. Illustrations copyright © 1970 by Sy and Dorothea Barlowe. (Pages 20, 38 top, 42, 44, 50 top, 58 top, 62, 63, 64 top, 67, 72, 73, 75 bottom, 76, 80 top, 82 top, 83, and 106; color plates 23, 24, and 25)

William Morrow & Company: Illustrations from *The Minnow Family* by Laurence Pringle. Illustrations copyright © 1976 by Dot Barlowe and Sy Barlowe. (Pages 53 bottom right and 54 top right)

Newsday: Illustrations of Dot and Sy Barlowe from *Newsday,* the Long Island Newspaper, issue dates 3/16/75, 8/17/75, 5/8/77, and 5/13/79. (Pages 38 bottom left, 58–59, 98 top, and 100–101 bottom; color plates 4, 7, 10, 11, 20, and 27)

The New York Times: Illustrations by Sy Barlowe from the "Long Island Weekly" section of *The New York Times,* issue dates 7/1/79, 10/28/79, 12/23/79, and 10/12/80. (Pages 37 bottom, 38 bottom right, 47 top, and 64 bottom)

Random House, Inc.: Four illustrations from *Who Lives Here?* by Dorothea and Sy Barlowe. Copyright © 1978 by Dorothea and Sy Barlowe. (Pages 18–19, 33, and 81 top and middle; color plate 5)

Time-Life Books Inc.: An illustration by Dorothea and Sy Barlowe from the *Reptiles & Amphibians,* "Wild, Wild World of Animals" series, courtesy Time-Life Films. (Page 78)

Vineyard Books, Inc.: An illustration by Dorothea and Sy Barlowe from *The Total Book of House Plants,* copyright © 1975 by Vineyard Books, Inc. (Page 98 bottom)

Western Publishing Company, Inc.: Illustrations from *What Is an Insect,* illustrated by Dorothea Barlowe. Copyright © 1976 by Western Publishing Company, Inc. (Page 70 bottom) Illustrations from *Amphibians of North America,* illustrated by Sy Barlowe. Copyright © 1978 by Western Publishing Company, Inc. (Pages 74, 75 top, 80 middle and bottom, and 81 bottom; color plate 26) Illustrations from *What Is a Flower,* illustrated by Dorothea Barlowe. Copyright © 1975 by Western Publishing Company, Inc. (Page 103; color plates 17 and 21) Illustrations from *Seashores,* illustrated by Dorothea and Sy Barlowe. Copyright 1955 by Western Publishing Company, Inc. (Pages 50 bottom and 59 top left and right; color plate 8)

DOROTHEA and SY BARLOWE are successful free-lance artists whose work has appeared in dozens of books, magazines, newspapers, and scientific journals. They began their careers in the 1940s at the American Museum of Natural History in New York City, where Dorothea was a staff illustrator and Sy worked in the Preparations department.

The Barlowes were married in 1946 and started free-lancing in 1950. They have continued to do so ever since. Their work has won several book awards and has been exhibited at the Society of Illustrators in New York and at Expo '67 in Montreal, as well as in galleries on Long Island. Both teach courses on how to illustrate nature and botany at the Parsons School of Design.

For the Golden Press, the Barlowes have illustrated fifteen books, including a number of nature identification guides, such as *Seashores, Trees of North America,* and *Amphibians of North America.* They have done nature features for *The New York Times* and *Newsday,* and have illustrated nature books for Knopf, Random House, Morrow, Follett, American Heritage Press, Putnam, Harper & Row, McGraw-Hill, and Grosset and Dunlap. In addition to the books they have illustrated, the Barlowes have contributed illustrations to several Audubon Society field guides and to *The Audubon Society Encyclopedia of North American Birds, Encyclopedia Americana, Webster's New World Dictionary,* and other reference books.

Massapequa, Long Island, is where the Barlowes have made their home for the past 44 years. There they maintain a studio, where they work together surrounded by books and also enjoy listening to classical music, attending to the whims of three domineering cats, and keeping up with the artistic careers of their two children—Amy is a concert violinist and assistant professor of violin at Willamette University in Oregon, and Wayne is an award-winning illustrator of science-fiction books.